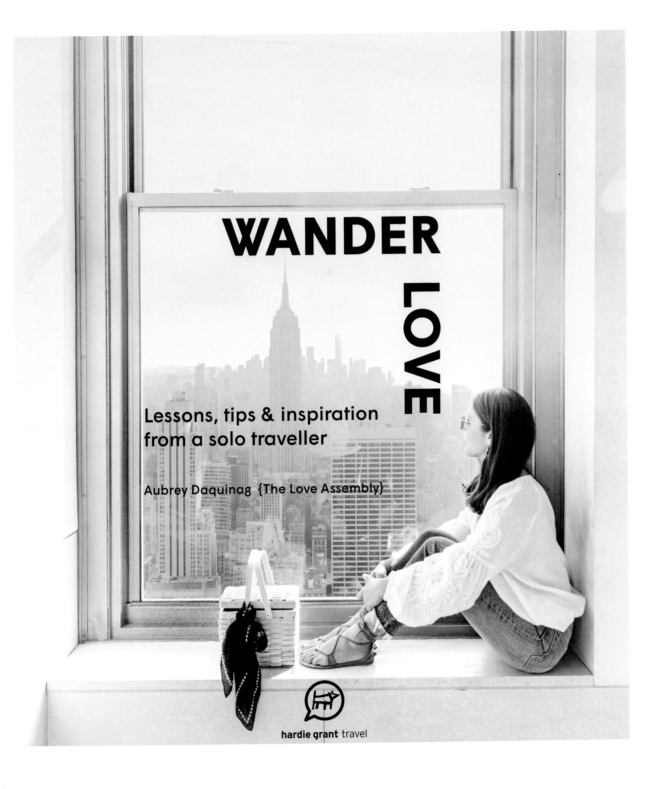

# WANDER LOVE

**Lessons, tips & inspiration from a solo traveller**

Aubrey Daquinag {The Love Assembly}

hardie grant travel

# WANDER

# A LETTER FROM ONE CURIOUS SOUL TO ANOTHER

Hey, hi, bonjour, konichiwa, hola!

**Date: Saturday 3 June 2017. Location: In transit MAD > RAK. Playing: Bonobo, 'Return to air'.**

I'm writing this while I'm 10,000 metres (35,000 feet) up in the sky, on my way from Spain to Morocco. Shortly I'll arrive in foreign lands and be immersed in a new culture again, a new way of living. Meanwhile, the guy sitting next to me has fallen asleep within 20 minutes of take-off and I fear my shoulder will soon become an involuntary headrest (not a very comfortable one, I might add).

After many years, I'm finally crossing Marrakesh off my bucket list. Thoughts are flickering like sparks in my mind and I'm questioning again why we travel … I've shared so many thoughts about the topic over countless hours up in the clouds and in conversation with strangers and friends while on the road. I can't help but believe that there are two sides to the act of travel: you can use it as an escape from everyday life, or you can use it as freedom – a way to free yourself to find a new reality that fills your life with purpose. The latter is what I have always been drawn to, and it's what I consider my personal definition of success – to wake up every day excited about working towards achieving my dreams. Why would I settle for doing otherwise? Why wouldn't I strive for what I want out of my one precious life? To live any other way just seems bizarre.

In a few moments I'll be landing in my dream destination, one that I've always wondered when I would explore. I've made a personal note to self: 'You did it! Stand proud. Keep going.' And *you*, my love, *you* can take yourself to anywhere you want to go, too. We're the ones in control of making the things we dream of happen for us – no one else.

I'll leave it at that for now, and see you on the other side (*see* Chapter 3, Wander Love Destination Guides: Africa: Marrakesh, Morocco, pp. 137–51).

→ Fast forward to yet another departure gate. They're calling for boarding. This time it's back to Australia for summer on home soil. I'm writing this letter to you for my debut book, *Wander Love*, where I share with you what it's like living in the *wanderful world* of The Love Assembly – starting with how the idea came to fruition, the office essentials you'll need to be a digital nomad and my favourite tools for managing a travel and lifestyle blog to help you create your own.

You'll also find travelogues aplenty, and sweet support to help you navigate the five stages of wanderlust. There are destination guides for six places around the world that my wandering heart has travelled to (with your heart waiting to do the same), as well as tips on hunting for treasures at markets around the world (including a lesson in how to barter like a boss). I share my advice on how to prepare for your solo travels, and take a deeper look at the topic

of 'travel' through philosophical thoughts on what it's like to travel creatively, curiously and mindfully.

From one curious soul to another, thank you, muchas gracias, merci beaucoup. I'm so glad to have you here. So thankful for the love and support. So excited for you as you immerse yourself in what's ahead.

If this book gives you only one thing, I hope it leaves you feeling inspired to unapologetically discover, become and be yourself through the adventures you take and the reality you create.

Travel to connect, explore and learn. Choose to live creatively and curiously, and take the path towards your dreams. And always, *always*, pack dancing shoes.

To wild wanderings and that groovy-kind-of-love …

Let's go!

**Aubrey**

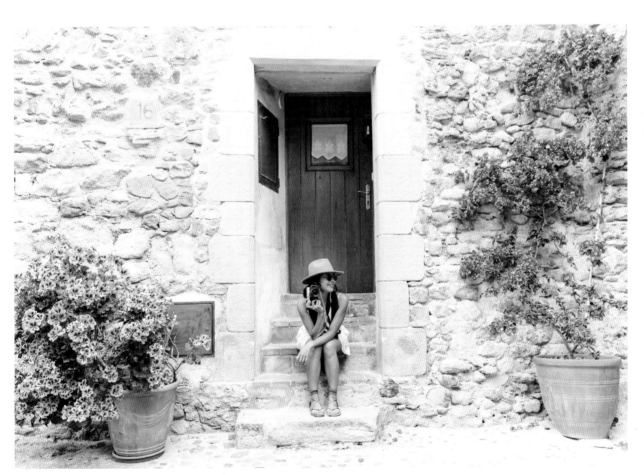

Happy with my camera in hand, on-location in the quaint medieval town of Pals, Spain with Catalonia Tourism

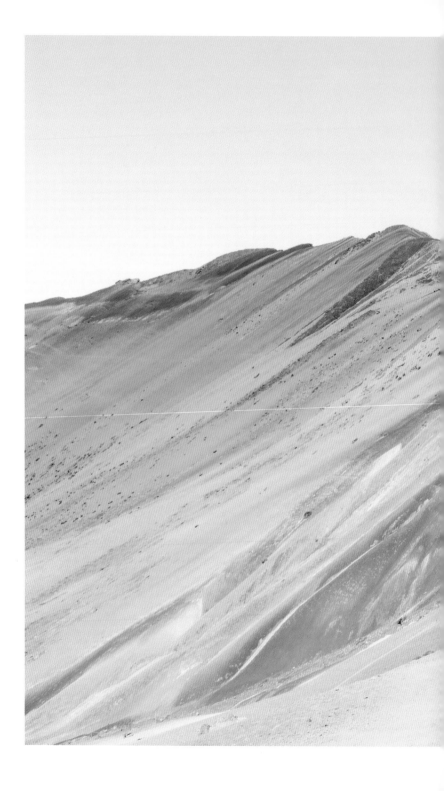

Made it to the top — my first solo hike.
Rainbow Mountain, Peru, 5000+ metres
(16,000+ feet) above sea level.

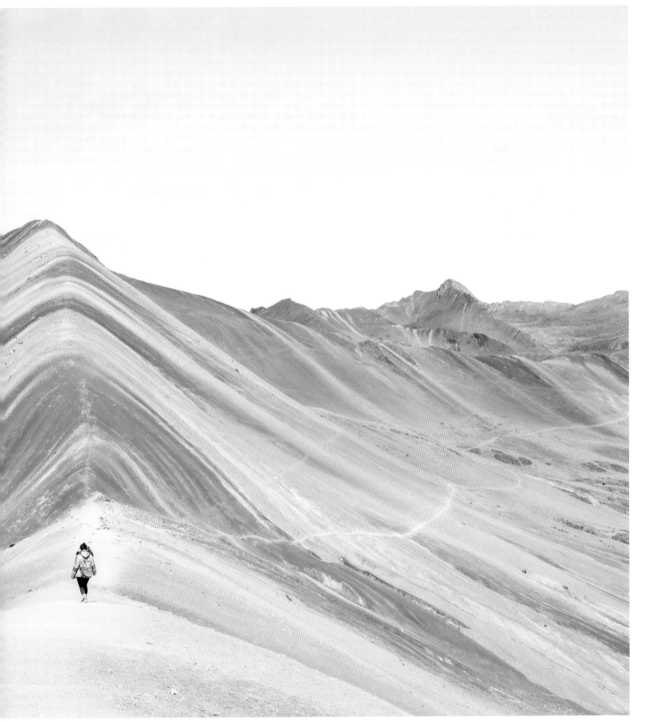

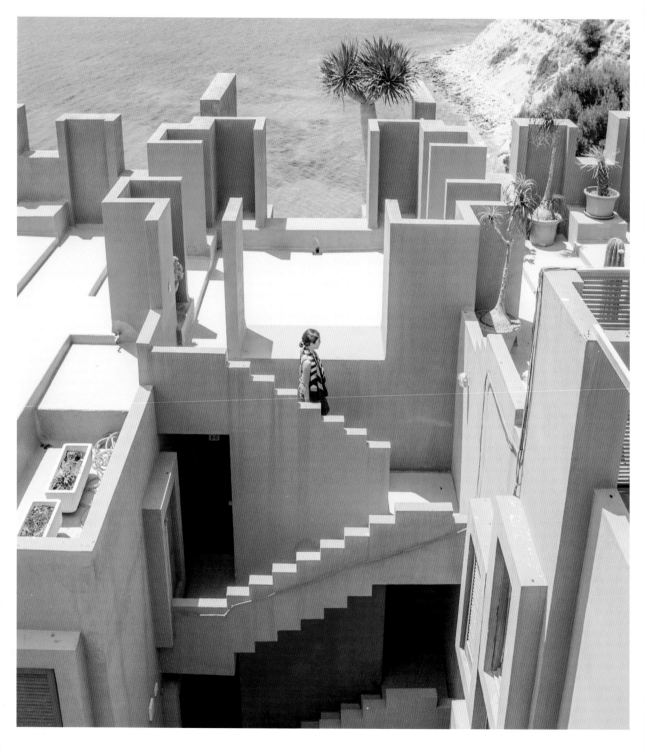

# 1.

# THE LOVE ASSEMBLY: A WANDERFUL WORLD

'What are you?' he asked.
'To define is to limit,' she said.

When I meet someone new, there isn't
a one-word answer I can give to the
inevitable question 'What do you do?'
Travel photographer, content creator,
digital media consultant …

On Instagram the first post of
@theloveassembly reads:
'Your dream job doesn't exist.
You must create it.'

PREVIOUS A walk through a colourful seaside dream at Muralla Roja, Spain
OPPOSITE Poolside on Sumilon Island in the Philippines

Always working from cafes around the world. Mozaic Living in Quezon City, Phillipines.

I chose to quit my full-time job many years ago to follow my dreams without having a concrete idea of how I would do this. We're told that if we do what we love then we will never work a day in our lives. I've frequently forgotten what day it is ever since I took that leap because living for the weekends doesn't exist anymore. Every day has become an opportunity to work on something that I love.

I've been sharing my thoughts, photos and stories on The Love Assembly for just over five years now. It's a digi-destination that was born out of pure curiosity, and it has been carving out a way to experience travel as a lifestyle rather than an escape from reality. It's driven by the creativity and curious nature of my mind and fuelled by big dreams (and copious amounts of caffeine, if I am completely honest). The kinds of dreams that scare and excite you at the same time; these are the kinds of things that are worth doing.

When I asked my heart at 3am one morning what I wanted to do with my life, three things were clear:

1  I wanted to create (and not be limited).

2  I wanted to inspire others.

3  Making money was not my overriding purpose but hey, a girl's gotta eat.

## QUESTIONS I ASKED MYSELF / QUESTIONS TO ASK YOURSELF

→ *If money were no object, what would you like to spend your days doing?*

→ *What activities make you lose track of time?*

→ *What are your interests?*

→ *What sort of impact do you want to make on the world?*

→ *What do people normally ask you for help with?*

→ *What do you find easy to do that other people find difficult?*

After asking myself these questions it was clear to me where the calling of my real work lay, and that I currently wasn't where I was supposed to be.

More importantly, I realised that nothing was forcing me to stay, and I had complete control of where I could go.

Coffee: check. Laptop: check. Wifi connection whilst glamping on a Melbourne rooftop at St Jerome's Hotel: check. Welcome to my office (for now)

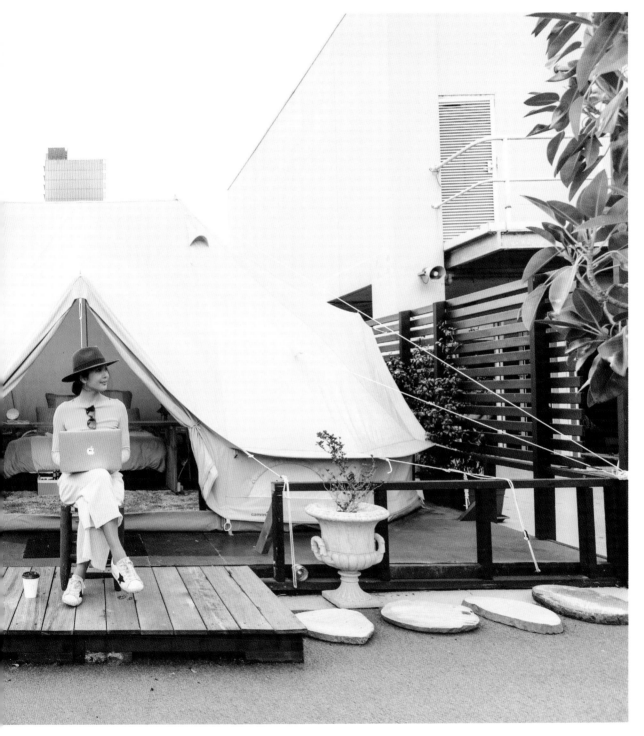

**We are drawn either to familiar people and places which we can relate to, or to those about which we know nothing – and desire to find out more.**

This was the seed for TheLoveAssembly.com and the first set of stories published on its launch: Q&As with creative individuals who were mostly my friends and people I had met through my previous jobs. They included a flower enthusiast who turned her love into a flower styling business and a fashion publicist who saw a gap in the market for a boutique fashion college. I was sharing the stories of inspiring people who were doing what they loved; hence the name. The blog was born.

I then chose to take time out to travel for a couple of months, relishing new destinations and revisiting the familiar, experiencing different cultures that intrigued me. India, Bali, Europe and the Philippines were all on the list. All I had was the drive to pursue my dreams, the curiosity to see where they would lead and the courage to take that leap. When I think about it, that's all that you need to take the chance to achieve your dreams, together with an awareness that at first you won't have all the answers and you'll learn along the way – you need to grow your wings and learn to fly. That's how I turned my travel dreams into reality.

While on vacation, taking photos came naturally to me, quests for cute cafes and cool activities were continual, my mind was constantly challenged, and inspiration was always at a high, as it is when you first set foot in a foreign place.

Over time The Love Assembly evolved into a lifestyle destination and the name took on a new meaning focused on travel and style, with a touch of inspirational content that encouraged a positive and uplifting attitude towards life (we all need reminders once in a while). I documented each of the places I visited, collecting and curating all the things I loved in a destination. I shared style stories and photographic diaries, as well as travel tips and destination guides. Then I began to be approached by companies that loved the way I produced my travel content and asked me to travel to new places to document them. My international trips had a new purpose, such as photographing images for tourism boards, and partnering with magazines and brands to create art and marketing material content, all the while getting paid for it – when once I travelled solely because I enjoyed it.

That's the trick to getting work you love: you first need to do the work you love. It leads to new doors opening, and new opportunities being revealed. Finding work that fulfils you begins with the small decisions that you make every single day; from the pursuits of passion performed on a daily basis, for free; from the things that you do out of the purest forms of interest and curiosity.

Whether you're living creatively to light up your life a little or to pursue it as a career, underneath it all this lifestyle is about taking risks: experimenting, testing and learning, and striving to create work of value that you can believe in.

Stunning views at the Gardens of Versailles, France

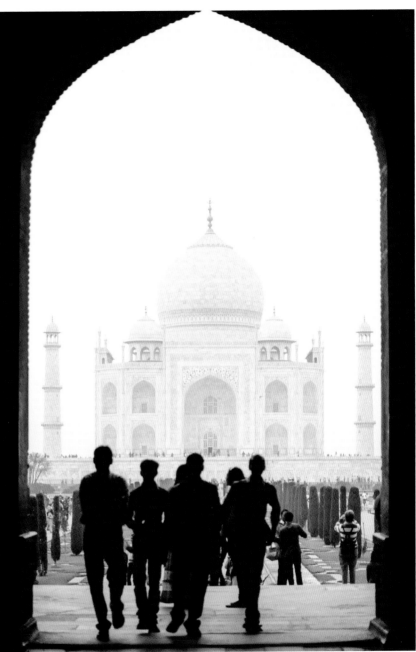

The first New Wonder of the World I crossed off my list: Taj Mahal, India, in 2012

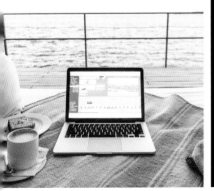

Video editing travel diaries while overlooking Lake Titicaca in Puno, Peru

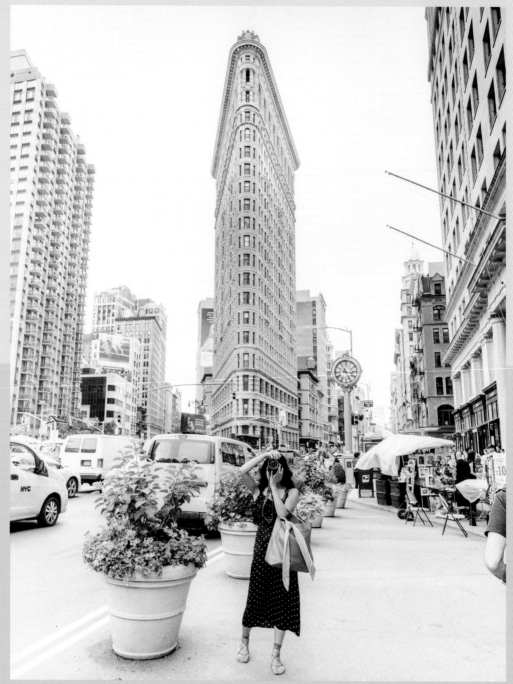

Photo of me taking a photo of you, in front of the Flatiron Building in
New York, USA

# THE ESSENTIALS OF A DIGITAL NOMAD'S OFFICE

I feel like I'm most productive when I'm on the road, or at least when I'm somewhere new. Maybe it's because there's always an ever-changing time limit on work hours, dictated by everyday deadlines (you know, deadlines on top of your actual deadlines): hotels to check out of before 10am, flights due to land after 8 hours plus of travel, even co-fficés (that's a cafe office) that require a constant scan of surroundings to determine when I've overstayed my welcome and it's time to bounce (because you and I both know that I'm there partly for the free wi-fi). The time pressure makes me edit photos, write content, prepare pitches and hustle on emails more efficiently, I suppose. It's some kind of forced Pomodoro Technique, though with slightly longer timeframes.

For work like blogging, my travelling office requires only a handful of necessities to continue running business as usual: laptop and charger, headphones, hard drive, camera, mobile phone, and a sense of curiosity. It's all I really need to be able to get my work done, anywhere – just as long as I'm logged on to a strong wi-fi connection … and kinda, maybe – well, always – get a good caffeine hit, too.

Cawfee, ploise!

Then I do the things …

## MY FAVOURITE DIGITAL TOOLS

**Booking my home away from home (accommodation):** airbnb.com, agoda.com, hostelworld.com

**Visual travel and photography inspiration:** pinterest.com, instagram.com

**Website management and blog creation:** wordpress.com

**Client pitches and presentations:** canva.com

**Creative collages:** procreate.art, picsart.com

**Vlog and video editing:** iMovie, Premiere Pro

**Website design templates:** themeforest.com

**Images and document sharing:** dropbox.com

**Newsletter and 'love club' email subscription:** convertkit.com

**Email:** gmail.com

**Client meetings:** skype.com

**Music playlists:** spotify.com, Shazam

**Photo editing:** lightroom.adobe.com

**Keeping in contact with loved ones:** whatsapp.com

Through the looking glass at Top of the Rock, New York

Matcha ice-cream in Kyoto, Japan. Oishii!

Pastel delight after Temps de Flors flower festival in Girona, Spain

But first, coffee ...

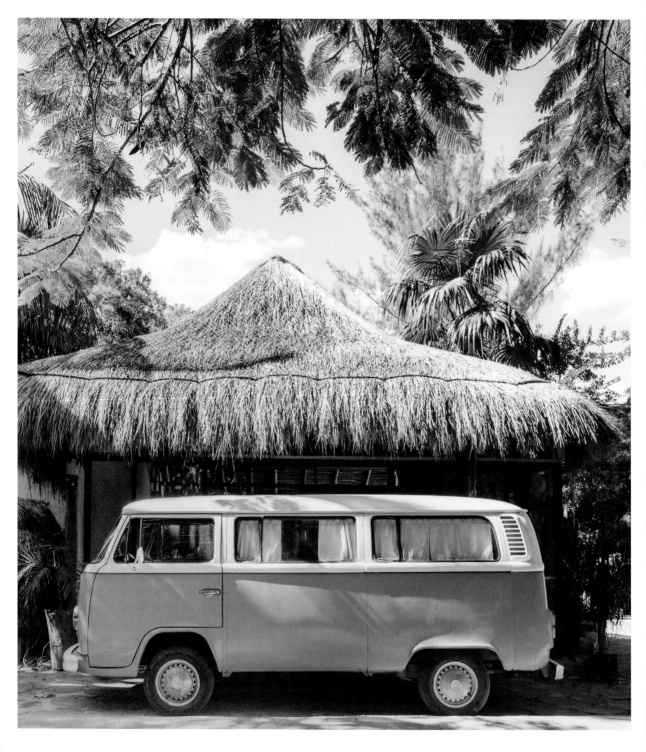

# 2.

# THE STAGES OF TRAVEL

# TRAVEL DREAMING

**LA VIDA ES BONITA.**

These were the first four words I learnt in my first Spanish class in Cusco, Peru.

From early adulthood it had always been a dream of mine to travel on my own for at least two months to a destination where I knew absolutely no one and English was not the first language. You might have a travel dream to go swimming with the giant turtles on the Galápagos Islands, journey through South-East Asia with only one backpack, or live in a foreign country for a year. Whatever it is, a travel dream is where it all begins.

You know those places that you dream about, the ones that exist in the pictures that you paint in your head and that you've only seen in photos captured through the lenses of others? You're drawn to those places for a reason: they chime with your interests and intrigue you, leaving you wanting to find out more. Let your imagination run wild and free – the first step of travel dreaming is only the beginning of an exciting adventure!

'Life is beautiful' is what the first four words opposite translate to in English. It's a phrase that I have kept close from the moment I scribbled it in my pocket-sized Moleskine on my first trip around South America. Solo. And damn, that trip felt good. Was it a taste of the travelling life that left me eager for more? I'd be lying if I said no.

**Life is so beautiful.** Our world is so beautiful. There are so many things to do. So many places to see. So many people to meet. Take the chance. Feel the fear, and do it anyway. That's exactly what I did. Our young hearts yearn for adventure.

**DREAM BIG.**

PREVIOUS Kombi van life in Mexico
OPPOSITE TOP First words my Spanish teacher taught me: life is beautiful
OPPOSITE BOTTOM Pastel architecture in Calpe, Spain

Let's go somewhere, anywhere

It all starts with a little dreaming and scheming …

## STEP 1

### CREATE A VISION BOARD OF YOUR TRAVEL DREAMS

Include pictures, words, objects, dates – create a thoughtfully curated collection. This process will help turn thoughts of the things you want to do that are aimlessly floating around in your mind into something that you actually end up doing. Having a visual and more tangible representation helps you gain a clear perspective on WHAT it is you really want to do, WHY you want to do it, WHERE you want to go and WHEN you want to achieve it. It's a way of manifesting your dreams and making them come to life.

The HOW shortly follows …

## STEP 2

### DO YOUR RESEARCH

After you have mapped out a concrete idea of what your dreams are, the second step is to look into the realities of achieving them, and align or realign your goals from there. This is the part where you choose to focus on a specific travel dream. Put your travel agent hat on and get online, or alternatively book an appointment with a real travel agent to pick their brain. Either way, you want to scope out the logistics here: flights, accommodation, cost of living, travel insurance, activities, how much money you will need to save and the best time of year to travel to that destination.

Everybody has their own travel style and the way you organise your travel should be natural to you.

A moment of R&R by the sea at Sumilon
Island, the Philippines

## Two ways to research a destination

→ *Word of mouth*
Ask around – talk to friends, family, colleagues, the person you're sitting next to on the train. People love to talk about their travels, and getting advice firsthand from someone who has already been to a place is always a great source of recommendations. Take notes.

→ *The interwebs*
Ah, the glorious interwebs. You can skip the first method if you want and get all the information you need by trawling through blogs, online magazines, review-based websites and social media – Instagram and Pinterest are my faves. Create individual destination boards and save all of the photos that appeal to you in each. Also look out for geo-tags and any other information that people provide on the WWW in the captions.

## Booking in advance versus spontaneity

Booking ahead will always be a surefire way to limit stress on your trip and almost always helps you save on the ca$h money. More than anything, the cost of flights will depend on whether it is low or high season, but booking early (6–9 months before departure) will ensure the best price. (This I asked my travel agent friends for you btw, because y'know, I'm sweet like that.) While short stays at hotels or hostels can be nabbed last minute for a bargain, you'll find that accommodation for longer periods of time is generally offered at discounted or better rates. When booking restaurants and activities, it's best to check for availability through their website and enquire how flexible they are with changes to bookings. I always like to take a peek at a restaurant's menu, too. Anyone else as keen as me? Nothing wrong with knowing your options and being prepared!

Although I'm all for planning and booking in advance, I always leave room for spontaneity, be it as simple as keeping a couple of afternoons free to explore a new part of town after Spanish class or something as daring as a whole two months to just 'see what happens'. It's true that the anticipation of a trip extends the life of that trip, feeding you with excitement as you educate yourself about the place you will visit, but picking up information and tips when you're actually in the country also makes your travel experience more personal and unique. If anything, research loads but *always* leave room to wander – that's part of the magic of travel.

## STEP 3

## SET UP A PLAN OF ACTION

The next step is a logical one, but it's a significant step that will switch your mindset from 'I want to do this, this and this (but I'm never actually going to do anything about it)' to 'This is what I'm going to do and here's how I'm going to do it.'

Create a detailed outline of everything that you need to do – and I mean *everything*. You're dreaming big. Sometimes you can feel so absolutely terrified by how much work is actually involved that you never even end up trying. However, the purpose of this outline is not to scare you but to give you smaller achievable tasks to tick off that will all contribute to the big goal. Kind of like receiving high-fives in a long distance race – reward yourself for the little things and it will keep you going. Next, write a date beside each task as a deadline. These will keep you focused, and be strict about sticking to them. (You're doing this for you, remember.) Then allocate a few moments of your time every week to completing one or two of the tasks, bringing your dreams closer to reality.

The outline doesn't need to be complicated. I've found a simple template works best, as long as it includes *What*, *Where*, *Why* and *When*, and then *Things to do* and *Date*.

Your outline might look a little something like this:

**WHAT:** Travel solo for at least two months

**WHY:** To challenge and learn more about myself

**WHERE:** Somewhere I know no one and English isn't the first language

**WHEN:** Before I turn 30

**THINGS TO DO / DATE:**

→ Choose a destination to hold the 'first place I travelled to solo' title / 28 February

→ Set a budget of $X for the trip / save $Y every week (you can set up an automatic debit from your account every payday to direct it into a 'travel savings' account)

→ Book flights and accommodation / 31 March

→ Apply for visas (if needed) / 31 March

→ Buy guide book on destination / 15 April

→ Research restaurants to eat at, best hikes to do in the area and favourable sights to see / 30 April

→ Learn how to say basic phrases in local language – practise using language apps such as Duolingo / 15 May

→ Download the Google area map of destination to use offline (a solo travel must that provides you with your location sans wi-fi connection to give you peace of mind) / 31 May

→ Check you have taken care of all necessary paperwork / 15 June

→ Make copies of your itinerary for family and friends / 22 June

→ Say 'sayonara' to family and friends – organise an intimate lunch and/or dinner for 'farewells' and 'take cares' / 22 June

→ Have a little boogie to uplifting music – because the dreams are becoming a reality in T minus 3, 2, 1 … and it feels so good to wiggle ya parts to vibrations! / 29 June

→ Go to airport and take obligatory departure gate photo to make all your friends jealous: #donthatemecozyouaintme / 30 June

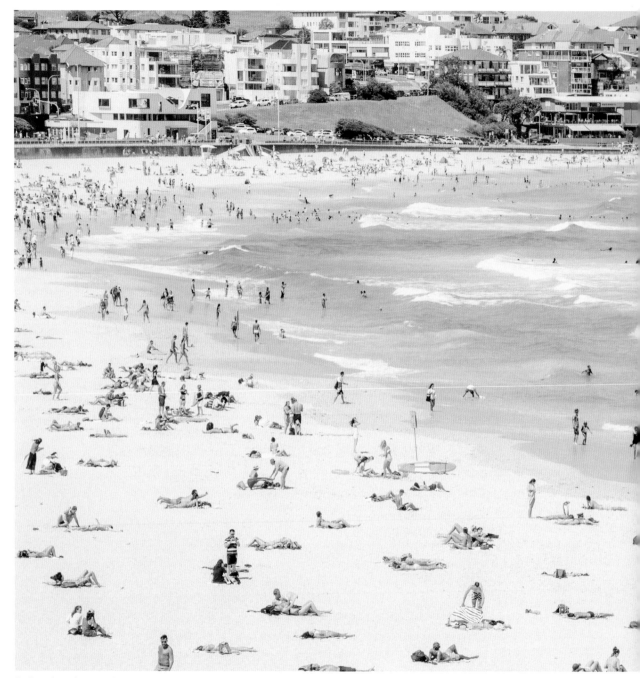

And so, the adventure begins ... Bondi Beach in Sydney, Australia

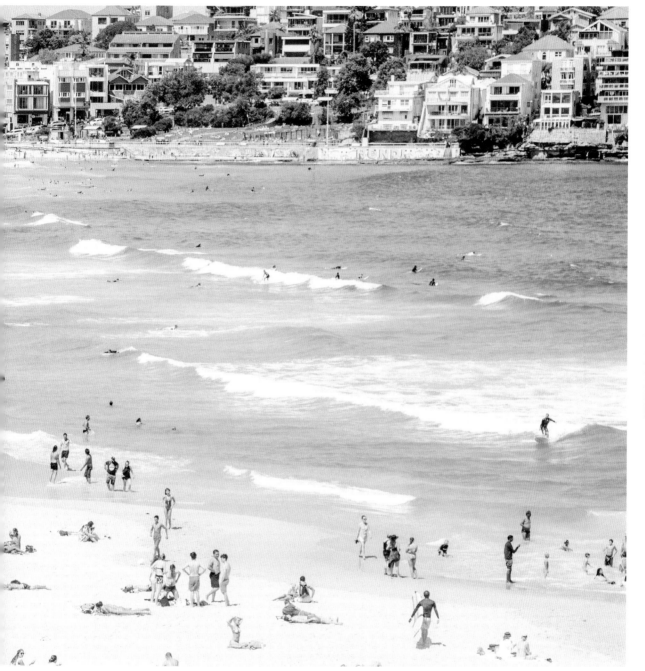

Style is a way to express yourself, without having to speak

# STYLE ON THE ROAD

Your style expresses who you are without you having to speak, and whether you love or loathe it, you ain't going nowhere without packing your bags first.

There are three things you want to tick off your list when preparing your style on the road:

**1**   You don't overpack – remember, less is more.

**2**   You respect different cultures.

**3**   You look cute (duh).

I've learnt a thing or two about style around the world, from the way Melbournians and Londoners have mastered the art of layering to how a scarf can be one of the most versatile items on a tropical island – i.e. it can transform from scarf to cardigan to sarong to top to head scarf (yes, one item, five ways – have faith!) – and how the Swedes do minimalism oh so well.

Travel is all about immersing yourself in each destination's culture. Embrace everything – the people, the places, the food and of course the fashion. My personal style is highly influenced by my travels and although I know I'll never actually be as chic as the French or as quirky and cool as the Japanese, it's fun to pretend to be.

I used to love packing, but when my days involved packing, unpacking, re-packing and doing that on repeat for two years, you could say my excitement levels dropped pretty quickly. On the up side, I have formed strategies and can definitely say that I've mastered the art of packing for a variety of different types of trips – from two months of solo travel out of two backpacks to extended travel across ever-changing climates – in just under 3 hours. I'm still surprised at how I was able to pack for both types of trip within that timeframe but yes, I did. And yes, I timed myself. Efficiency, people. Boarding gates are waiting!

**FIRST THINGS FIRST ...**

## THE STYLE BASICS

### The foundation

Start your travel wardrobe with a strong base of items in neutral shades of black, white and grey and the occasional piece of denim that you can build your look upon. It's all about separates that work well together which you can mix and match for different looks. For example, I'll pack a black cami dress with lace details that's perfect for a night out in heels or that I can wear with sneakers and my hair up for a casual day out. Versatility is key for these items.

### The colour capsule

This is where things get interesting! Choosing a colour capsule for each destination is by far my favourite part of developing a travel wardrobe. This was brought to my attention by a friend who noticed something in my photos that came naturally to me – I pack by colour, inspired by the hues reflected in my destination.

For example, Barcelona boasts beautiful, earthy tones that give out a poetic energy and golden light, not to mention that the city also holds the creativity of the works of artistic geniuses such as Dalí, Picasso and Gaudí. With this in mind, a combination of deep burgundies, burnt caramels and muted mustards on top of the foundation of black and white garments creates travel outfits that flow seamlessly between Barcelona and your look. Similarly, Hong Kong speaks of pastel on pastel and magical Marrakesh of mosaic-like patterns and prints.

Colour will create the difference between your holiday looks. It's a super simple element, yet so effective when you're crunched for time (and luggage space) because all of the pieces will effortlessly work with one another when packed as a capsule for a particular destination. Plus you'd rather be out there exploring the world than taking your sweet ass time getting ready, anyway.

Check the weather, be aware of the culture, draw inspiration from the architecture, try different colour combinations and add some personality with your accessories. Have a look at what other people, preferably the locals, are wearing in that destination for inspiration. When you've integrated foundation and colour co-ordination with location, watch the cute holiday pics roll in.

Now that that's sorted, let's move on.

Colour capsule containing lots of white,
earthy tones and a hint of print

Gaudi's creative work fills the city of
Barcelona, Spain

Blending in with Spain's golden hues

Self portraits in a pink paradise in Calpe, Spain

## THE STYLE ESSENTIALS: GIRLS

I'm going to let you in on a little secret … when it comes to minimal packing, it really is all in the accessories. Here are some simple style hacks to level up your travel wardrobe.

### A bright lip
Good skin is *always* in. Along with your beauty skincare pack, a pop of colour to your lips can instantly brighten the face and add colour to your look. Choose two shades that match your skin tone: one that's classic but still makes a bold statement and one that's fun but isn't too crazy to be worn throughout the day. These weigh close to nothing and make your look a little less ordinary. No cake face necessary.

### Earrings
Like lipstick, earrings weigh almost nothing but have the exact same effect on your look. Try different styles that you can mix and match, pair statement earrings with simple outfits for balance, and vice versa. A little bling bling works wonders.

### Sunglasses
Other than the obvious reasons of keeping the sun out of your eyes and preventing you from performing the squinty-eyed death stare in photos, these are a must. Sunglasses also serve the handy purpose of hiding those not-so-designer eye bags after a late night. No Gucci. No LV. No thanks! Speaking of the sun, always be sun smart and pack that SPF.

### Headwear
Enter the hat game when you're having a bad hair day or you're just lazy and don't want to wash your hair (hey, it's best not to wash your hair every day, or so I've been told). Your options? Fedoras are ideal for cooler destinations, straw hats for the summertime and berets for the in-betweens. Choose wisely. Wear confidently. Alternatively, experiment with different hairstyles …

### Hairstyles
Your hairstyle should suit both your planned activities for the day and your outfit. Instead of the usual ponytail, go for braids on each side that come together in a low bun or add a little something like a black ribbon to seal the ponytail deal. Even simply switching from a middle to a side part can immediately change your look from carefree to sleek and chic. New hair, who dis?

### Scarf
If there's one item that has multiple uses and is always a travel wardrobe necessity, it's a scarf. It doubles as a pillow, triples as a skirt (the lightweight option only) and has the ability to add new life to any bland outfit for a fraction of the price of an actual item of clothing. Choose wool or cashmere for cooler destinations, cotton or linen for the summertime and silk for the in-betweens. Pack multiple. Experiment with prints and patterns. Rotate styles frequently.

So … the moral of the story is that you can still look a billion bucks on your travelling budget.

Get creative. Add personality. Be cute, but cool (but cute).

## THE STYLE ESSENTIALS: GUYS

### Collared shirts

Hot tip for the men out there: the collared shirt is your secret weapon to versatile style on the road. It's casual enough to wear open over your daytime tees and you can instantly spruce up your look by buttoning it for dinner and drinks in the evening. Never leave for your trip without one in a block colour and one in a print. Opt for breathable fabrics such as linen and cotton.

… And I'm not just including this so that your girl can steal your shirt and use it as a cover-up on the beach. Or as a morning-after shirt. Promise ;)

### Cap

You've had a big night out and you're staring blankly at yourself in the hotel mirror. You have to be down to meet the group at reception in five. Skip the 'do (ain't nobody got time for that!), throw on a cap and grab a coffee at the closest cafe to get you feeling a little less zombie-like. For the man more adventurous in style: the fedora is your go-to (but you probably already knew that).

### Dress shoes

One more for the road: make sure you have a pair of dress shoes in your capsule collection. Why? It'll turn the classic jeans and tee combo into a semi-polished look and get you into places at night that require smart casual attire. Style tip: a pair in tan is always a good, versatile option.

Travel wardrobe with a strong foundation of neutrals

Wear a cap on days when you can't be bothered to deal with your hair

Smarten up a pair of chinos with a collared shirt and dress shoes

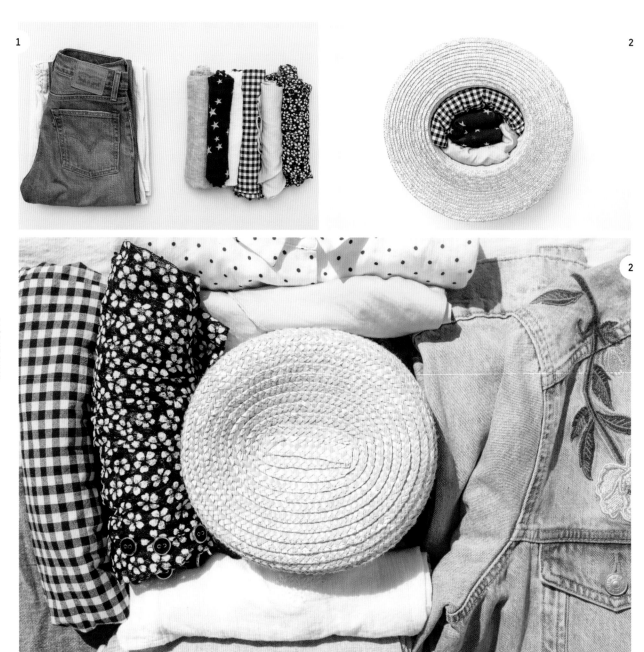

1

2

2

WANDER LOVE

## PACK YOUR BAGS BETTER

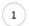 **Roll versus fold**

Ah, that great old debate on rolling versus folding – a topic of comparison like coffee versus tea, New York versus LA, tom-ay-to versus tom-ah-to. It's true that rolling your clothes is a more efficient use of luggage space than folding them – countless experiments have taken place and overload the internet. But in my own experiments, I've found that I like to do both:

Roll lightweight fabrics you wish to keep wrinkle free.
Tops, dresses, lightweight bottoms such as trousers, skirts and shorts, underwear … These are all pieces that are best when rolled because it compresses the garment and minimises wrinkles. Fold the item in half and get rolling. By pairing similar pieces and rolling them together you can cut the amount of time spent doing this in half.

Fold heavier fabrics such as sweaters and jeans.
There are items of clothing that are just too bulky when rolled up – these are the pieces that are best folded. Instead of packing the folded pieces horizontally on top of each other, place them all together vertically in your suitcase so that you're able to see all of your options instead of only the piece on top.

2 **How to pack a hat in your suitcase**

→ Gather all of the items you'll be packing along with your hat, and separate items by material and type: shoes, bags, lightweight fabrics like cottons and silks and heavier fabrics such as denim.

→ Pack your accessories in an even layer on the bottom of the bag. Keeping one item made of heavier fabric aside, place about half of your clothing on top of the accessories, creating a flat surface for your beloved hat to sit on.

→ Next, take the item made of heavy fabric that you've put to the side, fold it and then roll it up like a sushi roll.

→ Place rolled-up, sushi-like item inside the hat, aligning it with the bottom inside edge of the crown. This support will help to maintain the hat's shape.

→ There'll probably still be some empty space inside the hat; if so, fill it with another smaller piece or two of clothing in a lighter fabric. You want the inside of the hat to be completely full, but don't overdo it – the last thing you want is for it to stretch.

→ When the crown is full, place your hat on top of the flat surface you've made in your suitcase. Then pack the rest of your items around it.

→ Et voilà! A happy hat packed nice and snug, just waiting for some sun.

# CAPTURING MOMENTS

You've packed your bags and arrived in a foreign place, ready to immerse yourself – in the bustle of a city, the slow pace of island life or the isolation atop a misty mountain. Everything is new, every corner is exciting. Part of the fun of what lies ahead is capturing these moments through the art of photography. Or 'making time stand still', as I like to say.

The power of a photograph can transport you back to that time, place and feeling, but knowing how to achieve this requires the right combination of technique, tools and lighting – with a sparkle of creativity! A great photograph ultimately tells a story. Each destination holds its own charm, ambience and energy, and how you creatively capture it is how you tell *your* story.

Passport in one hand, camera in the other

## TIPS FOR BEAUTIFUL PHOTOGRAPHS

Anyone can be a photographer these days, but here are a few golden tips to make your photos stand out.

**Follow the light**

Light is an essential ingredient not only to travel photography but photography in general. Its availability (or lack thereof) determines how bright an image will be, and it also sets the overall tone, mood and atmosphere.

'The Golden Hour' is a photographer's favourite time to play – this happens twice a day, at sunrise and sunset, when daylight is softer, more dream-like, and has a certain glow. I'll admit that waking up at the crack of dawn can be difficult on your travels, but it's a decision you can never really regret after you've seen the fruits of your labour. You'll normally beat the crowds at this time too, meaning fewer people in the background of your shots and less post-processing of unwanted photo bombers. Always a plus!

Something as simple as the sun asking me out on a date, in Titlaka Hotel, Peru

**Research the location before you arrive**

Sure, winging it on a trip can be fun and you might be lucky enough to capture some great in-the-moment snaps, but let me tell you, in order to get the best photos a little preparation goes a long way. You'll be able to plan for shots during the research phase of your travel dreaming (*see* p. 19). Having a few ideas in advance about the sorts of shots you might like to take and the places you'd like to photograph will show in the end results by allowing you to create more visually stimulating photos.

Social media platforms such as Instagram and Pinterest are my favourite for research, followed by a quick scroll through travel and lifestyle blogs. Tourism boards showcase their must-visit hot spots on Instagram, and you'll also find curated travel accounts and those of photographers who lead globetrotting lifestyles. Pinterest acts as a search engine, so if you simply type a destination like 'Peru' into it, plenty of photos will pop up to inspire you.

It's thanks to Pinterest that I found the place where I did my first hike (proudly accomplished!). There was only one photograph that appeared in my 'Peru' search – it showed a guy sitting with his back to the camera on top of a candy-striped mountain, his arms outstretched. I got in touch with him to find out how I could do the hike because I couldn't find any tour companies that offered it. It turned out that he had found the track with his girlfriend of the time, and he offered to organise the hike to Rainbow Mountain for me. Back then, there were few tours to Rainbow Mountain; through social media his travel tour business was born.

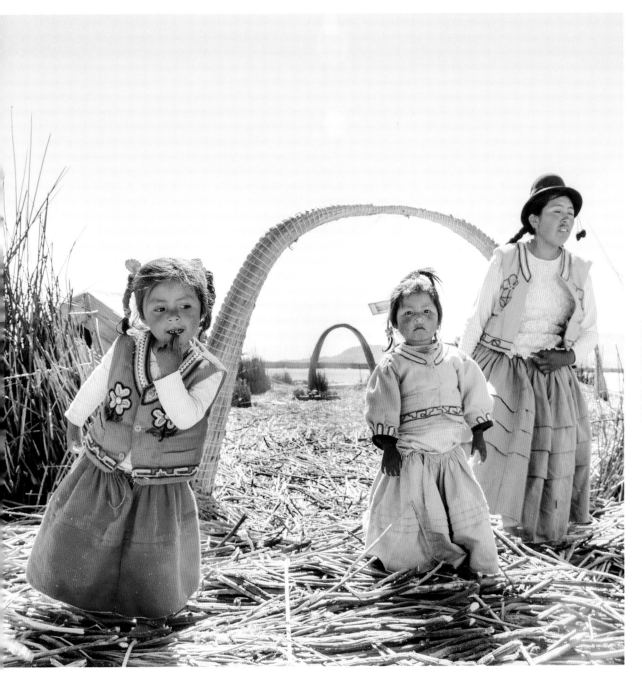

e colourfully dressed Uros people who live on floating islands in Lake Titicaca, Peru

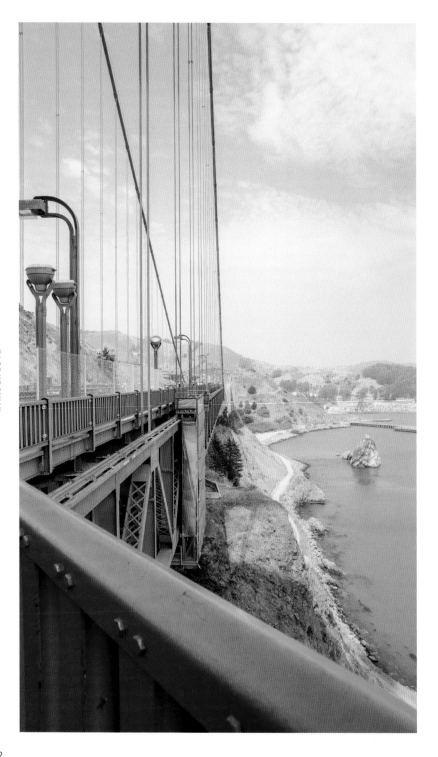

## Get creative with composition

The classic techniques that aid composition in photography include leading lines, symmetry and the 'rule of thirds'. **Leading lines** draw a viewer's attention to a specific part of the photograph, creating dimension and a visual narrative; sand dunes, a road or a row of lamp posts are examples of the types of features that can be used to create leading lines within a photograph.

**Symmetry** in a photo creates a sense of balance. The **'rule of thirds'** works by dividing the photo into thirds with two imaginary lines that intersect the frame vertically and two lines that intersect it horizontally, making a total of nine sections. You then align the main subject of the photograph along the horizontal or vertical guide lines to create a balanced and interesting composition.

You don't always have to follow these classic techniques. By breaking the rules and getting creative with your compositions, you can personalise your style. Think about it: your subject doesn't *always* have to be in the centre. Sometimes this is boring – switch it up and work with (and even against) the rule of thirds to keep things interesting.

## Experiment with your unique point of view

I'm always interested in how a person photographs a destination they're visiting for the first time. Two people can travel to the same place, spend the same amount of time there and do exactly the same things, but capture it all in a completely different way. No one will see it like you do. Experimenting with different points of view can give the viewer your perspective in abstract form. Try photographing from hip instead of eye level, at arm's length above your head or even on an angle. The choice of angle can instantly change what the viewer feels when looking at your photograph. Taking a photograph at the same level as your subject will provide a sense of equality, whereas a photo taken from above can convey a sense of power. Shooting from a first-person perspective – by including part of your body within the frame – lets the viewer see through your eyes and imagine themselves in your shoes.

OPPOSITE A walk along Golden Gate Bridge in San Francisco, USA

RIGHT A different point of view, Golden Gate Bridge

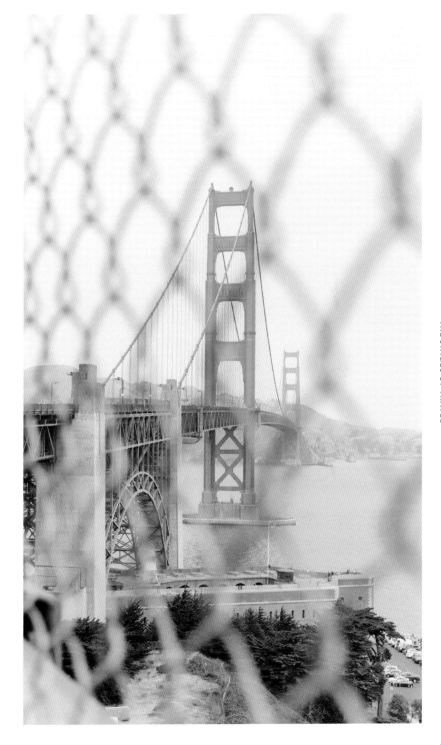

## Include people in your landscapes for scale

Because we humans are social beings, including people in landscapes not only adds scale by presenting how big and beautiful our world is but also makes the image more interesting overall. When you add an element from your personal travel experience into a landscape, the viewer can automatically relate to it in a way they can't to a landscape sans human connection.

For my travel blog photographs, I established an 80/20 rule early on: 80 per cent location, 20 per cent me. This explanation has come in handy whenever I've had to ask a stranger or friend to take a photo of me (*see* pp. 48–9 for more on how to take photos of yourself when travelling solo). Basically, I explain that I want the photo to be mostly about the destination I'm in, not all about me filling the frame, and I mention my 80/20 rule. Once I started to describe what I wanted using these figures, people seemed to understand my vision more.

## Tell a story

Ultimately a great photograph tells a story – *your* story. Interact with the people and connect with the places you photograph and it will notably improve and bring your images to life. When photographing people, evoke feelings and emotions through conversation with your subject – tell jokes, encourage LOLs, make them feel good. The goal is for them to feel comfortable, allowing you to capture them in a natural, non-forced way, with genuine expressions.

For an artistic edge, work with your style essentials (*see* pp. 31–2) to tie in the colour palette and details from your #OOTD with a location backdrop.

Always look up. Bamboo Forest in Arashiyama, Japan

### It's all in the details

One thing that I can honestly say I realised a little later than usual is that post-processing is just as important as the act of being in the moment and capturing the photograph itself. There's power in a good edit; it immediately takes an average photo and makes it look ten times more appealing through the adjustment of contrast as well as colours and their vibrancy.

Software and applications that I use to edit photos include Lightroom (mainly), Photoshop (hardly ever but occasionally for tweaks here and there, as well as collage work) and Snapseed (on mobile).

Unedited photo

Edited: exposure, curves, clarity and temperature adjustments

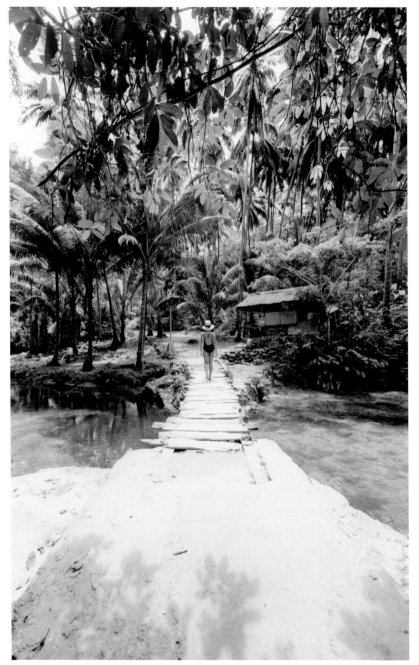

Barefoot and free in Cebu, the Philippines

## HOW TO TAKE PHOTOS WHEN TRAVELLING SOLO

Ever asked someone to kindly take your photo, only to look at the screen and find it's not how you had imagined it? Yeah, happens to most of us. An awkward smile and 'thanks!' normally follow. Then you're back to square one: on the hunt for the next person to ask for the click, hoping that they do a better job than candidate numero uno over there.

It's a tricky situation you'll find yourself in when travelling solo, and if you're like me, you will already know how you want the end result to look. My long stints travelling sans insta-hubby meant picking up tips and tricks to take better travel photos of myself was something that I had to figure out quick. (Though sometimes a stroke of serendipity happens and you actually end up finding an insta-hubby on the road – a personal love story for another time, I suppose.)

**The tripod trick**

<u>What you need:</u> A tripod (I use Manfrotto's Compact Action tripod), a camera with wi-fi connection (I currently use a Canon 6D), and a smart phone to connect the app to the camera (I use an Apple iPhone that connects to Canon's camera app).

The process is quite simple: set up camera on tripod, connect smart phone to camera's wi-fi connection for use as a remote shooter, then hop into frame and work those poses!

<u>Tip 1:</u> Always use the self-timer on your camera or phone to allow yourself a few seconds to get into the right position or pose.

<u>Tip 2:</u> Candid is always cool.

This method is most appropriate for when you want to capture beautiful shots in quieter locations like your hotel or villa accommodation. When it comes to public places such as monuments and landmarks, whipping out your three-legged companion isn't always the safest or least embarrassing option if you're travelling solo. Try this instead …

**The perfect insta-~~stranger~~-hubby trick**

It starts with scanning your surroundings for the right person: usually of the same generation and in possession of a DSLR camera. These characteristics reveal that (a) they understand how technology works and (b) they're into photography so there's no need to explain what button does what on your camera.

Now that you've spotted them, say hello and strike up a light, friendly conversation. Keep it cajj. Eventually lead to asking them to take a photograph.

Have your camera setting all ready to go – the last thing you want is over- or underexposed shots.

Take a photo first to show them the framing that you want, then give as much direction as possible, such as 'I'd love it with the bridge I'll be walking on in the centre.' Mention the 80/20 rule (*see* p. 45) if that's your type of thing, too.

Review the shot and say thanks.

# CREATING MEMORIES

One of the true joys of travelling is bringing home memories that you've created on your journey. It's not just about the sights that you see, but also the enlightenment of the senses as you wander into a new city, a new adventure. While great photos are one thing, there are also other ways to take travel memories home with you. I don't mean this in the sense of physical souvenirs but rather the unique memories planted within you through the act of travelling with your senses.

## SEE

Let's start with the obvious, shall we? A picture speaks a thousand words. Now that you've learnt how a marriage of certain elements can create a great photograph, store these images alongside your musings in a travel journal together with tickets, polaroids, maps and anything else you feel inclined to collect. Feel the flow and write words to accompany your visuals. Keep it raw and allow yourself to be completely vulnerable and honest. There's nothing to prove in journal writing; it's a creative outlet that gathers thoughts, feelings and memories for you to keep close and relive when the fancy takes you. You may find it is very therapeutic, too.

## SMELL

Just as a photograph can take us back to a particular time, place or feeling, scent has a majestic way of doing the same. It's the sense that's most closely linked to memory. The spices of Morocco, the ocean on a European summer holiday … a familiar scent can conjure memories, reminding you of 'that time when …'

Another way to create a scent that encapsulates memories of a journey is to choose a travel perfume. Work with light and floral scents for hotter locales or summertime trips, and something more warm and woody for chilly destinations. The captivating reminders will reveal themselves when you wear the scent once you've returned – let it take you back. To this day, Do Son by Diptyque still reminds me of my first time in Paris … feels just like yesterday.

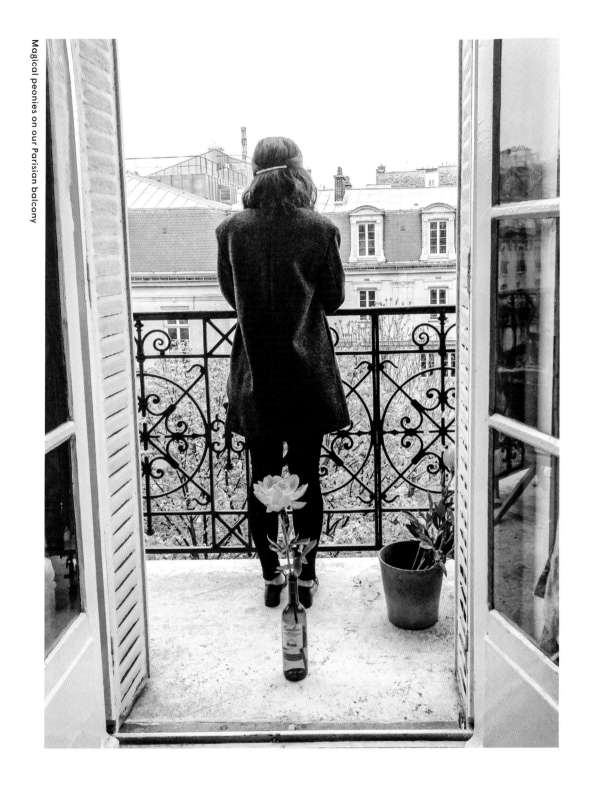

Magical peonies on our Parisian balcony

## TASTE

They say that the way to a Taurean's heart is through his or her stomach. Well, as a Taurean myself, I can vouch for this because (a) I love to eat (who doesn't!), but not just that, (b) I love to eat well. Food can often be a distinct characteristic of a destination. Whether you've gone on an exhilarating hunt for street food in Asia or worked your way through a degustation menu prepared by a passionate chef at an award-winning European restaurant, travel should always involve delighting the tastebuds with unique flavours. Take a cookbook home to re-create the dishes or flavours you've encountered on your travels.

A scrumptious seafood lunch in Spain

## HEAR

One of my favourite apps in the whole wide world is Shazam: it has a clever blue and white button that you click to identify the song and artist playing. It even displays the lyrics! Technology, man. Every time I travel to a new destination I create a Spotify playlist to collect the tunes that come up along the way. It's a modern-day mixtape, and boy did I love to create mixtapes back in the day. Now, my Spotify playlists aren't just any type of playlist; they're thoughtfully curated compilations of songs that I have collected from pretty much anywhere and everywhere on that trip. They include music native to the specific location (oui, French rap makes an appearance in my Paris playlist, merci beaucoup), as well as songs that I like and Shazam while taking cab rides, in cafes where I've worked and people watched, in bars and clubs, in transit at the airport. Even the names of the playlists are filled with meaning: 'Still in Mexico' plays on the word 'still' because it includes tunes from my yoga retreat in the coastal town of Tulum; 'Colombia, mi corazón beats for you' (which translates 'Colombia, my heart beats for you') is a mix of upbeat Latin songs, as all I wanted to do there was go to dance classes and dance (which I happily did); and, from simpler times, 'Hola España' for my first time in Spain – pretty self-explanatory.

## TOUCH

How can we create something as heartwarming as touch during our travels, and take it home with us? The answer is through a spiritual sense rather than a physical one, through genuine human connection and interaction. That's how. Touching someone and being touched by someone on our travels enhances our experience and rewards us on the inside. The opportunity arises when we're open, curious about others and their stories, willing to put ourselves in a position from which we will give rather than receive. You'll find that getting involved in the local community – perhaps by volunteering at orphanages or for development projects – is the most straightforward way to accomplish this on your travels. But it can also happen when you choose to interact with the people you come across – you never know where one conversation may lead you, or where random acts of kindness can take you. To know that you have truly inspired another person or made a positive difference to someone's life is one of the best feelings in the world. It's a memory that will last a lifetime for both of you.

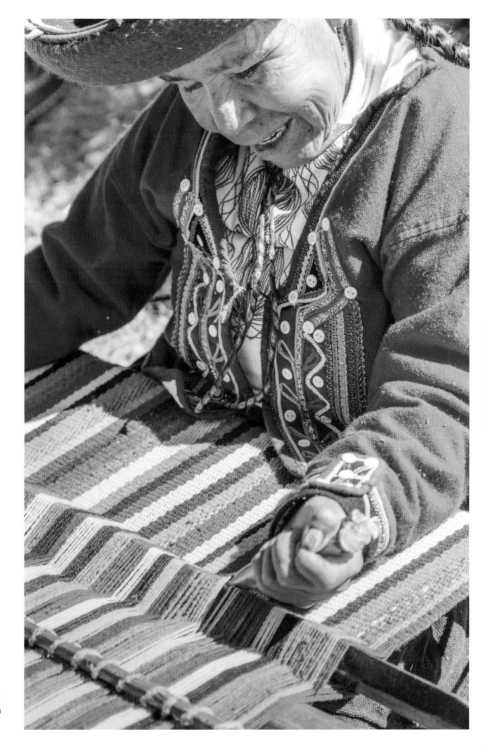

Hand weaving technique passed
on from generation to generation
in Peru

# BRINGING YOUR TRAVELS HOME

Travel souvenirs from beloved journeys can serve as more functional reminders. They personalise your house and turn it into a home, and often spark conversation with curious guests. With a little rearranging and decorating, you can style the treasures you have collected and liven your space with your worldwide wares. Here are some ideas for displaying your travel mementos.

## Create a photo feature wall

The majority of the time our travel photographs only appear online. It's amazing how much more value an image holds when it's enlarged, printed and nicely framed. Select a few images to become fine art prints. Dedicate a feature wall to your best work and most memorable moments.

## Beautify that bookshelf

A simple and creative way of storing the trinkets and treasures you collect on your trips is in decorative storage boxes. Purchase a few boxes of the same style: wooden for a rustic feel or crisp white for a minimalist approach. Write the name of the destination on the outside of the box and simply fill 'er up! You're essentially creating a travel time capsule that keeps all your travel mementos organised. The boxes are also pretty little additions to any bookshelf.

## Be the most stylish couch potato out

Pimp your lounge with cushion covers from around the world. You can do this with your bedding, too! The style of each piece doesn't need to be the same – it's actually more interesting if you mix and match – but make sure you stick to a similar theme or colour palette so that the overall look is coherent with the rest of your home's decor.

## Display and decorate

Often the pieces that I purchase when I'm visiting a destination are practical items to wear on the trip; other times I'll buy something because I feel it's not *just* a dress but a wearable piece of art. Handmade works deserve the decor spotlight, so showcase them throughout your home: display that beautiful dress on your bedroom wall; hang Peruvian pompom key rings from door handles or the end of curtain rods; create themed mini installations with travel trinkets like ceramics, figurines and shells and a little imagination; or simply thoughtfully style your collectables on your coffee table.

Travel treasures from Colombia, France and the Philippines on display

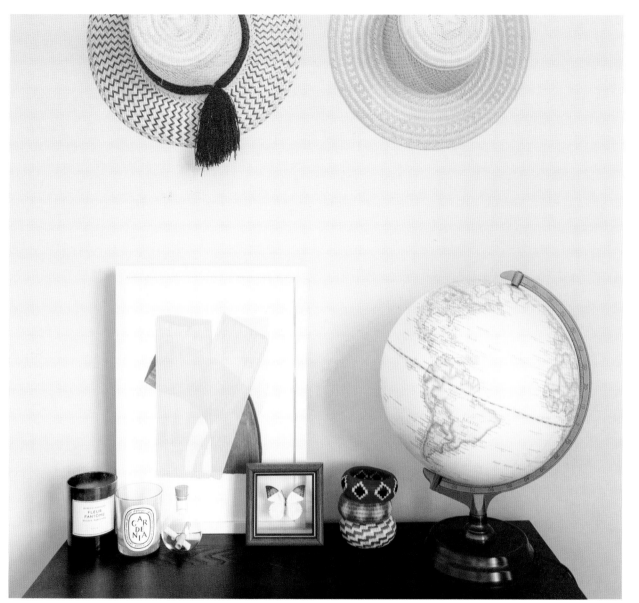

## TRAVEL TIP

Choose items that represent the local culture – be it embroidered textiles from India, baskets from the French Riviera, or rugs and sequinned wedding blankets from Morocco. Try not to stray from your personal style and your home's overall aesthetic to avoid unnecessary purchases that will end up forever in storage.

It's nice to be in Venice

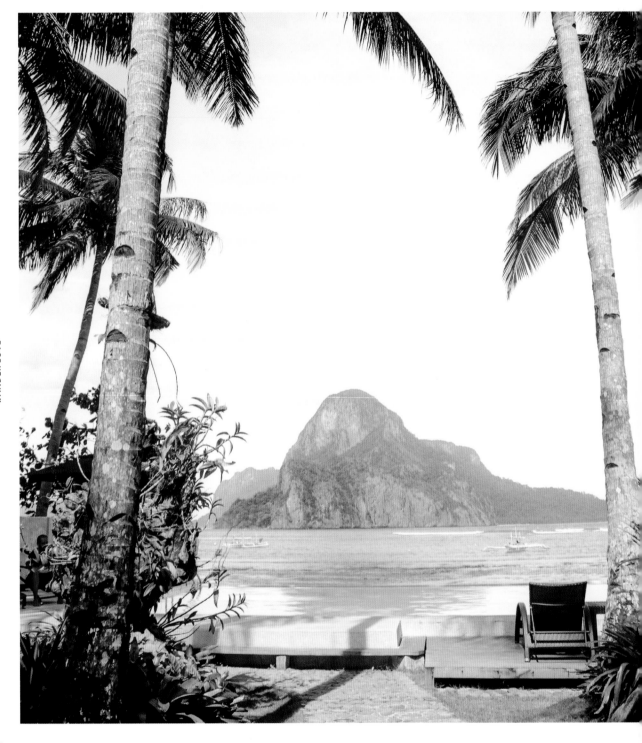

# 3.

# WANDER LOVE
## DESTINATION
## GUIDES

'What's your favourite place in the world?'

_____

While I spend a lot of time crossing borders and crossing places off my bucket list, it's hard to give a simple answer when people ask me that question. Every destination I've been to has its own charm, story and memories.

I've left a piece of my heart in so many of the places I've visited around the globe – from Mexico to Morocco – as well as a part of me in the cities I've called home.

These six destinations that my wandering heart has travelled to are guaranteed to excite and enlighten you. Every guide holds a thoughtful curation of the best places to eat, shop, stay and play, and also provides a collection of style and travel tips for a little something extra. Each place is a bit different to the next …

OCEANIA: MELBOURNE, AUSTRALIA

EUROPE: BARCELONA, SPAIN

SOUTH AMERICA: CARTAGENA, COLOMBIA

NORTH AMERICA: TULUM, MEXICO

AFRICA: MARRAKESH, MOROCCO

ASIA: PALAWAN, THE PHILIPPINES

PREVIOUS Majestic views in
Palawan, the Philippines

TOP LEFT Bathing boxes at
Brighton Beach
TOP RIGHT All the good stuff
in Collingwood
BOTTOM Crossley Street
laneway, just off Bourke Street
in the city centre

# OCEANIA:
# MELBOURNE // AUSTRALIA

From its famed coffee and cuisine to its Gothic-style architecture and hipster art scene, Australia's cultural capital has inspiration around every corner. Melbourne is a cool and creative destination, frequently ranked as the world's most liveable city (seven years in a row now and counting), and one that I called home for just over two years. The abundance of live music venues, rooftop bars with views you can't beat, street art–filled laneways and hidden charms to discover means no day exploring could ever be dull.

When visiting Down Under don't forget to schedule in Sunday brunch, a weekend ritual for most Melbournians. And if you're wondering how you can blend in with the locals, just wear black. A lot of it.

Then order smashed avo' on toast. Always.

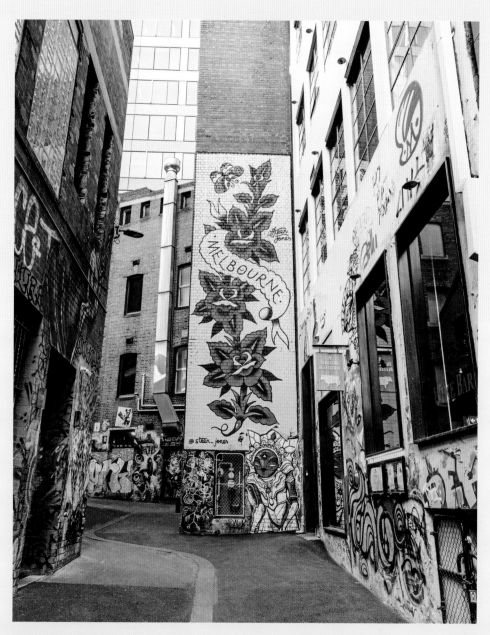

**Street art in AC/DC lane**

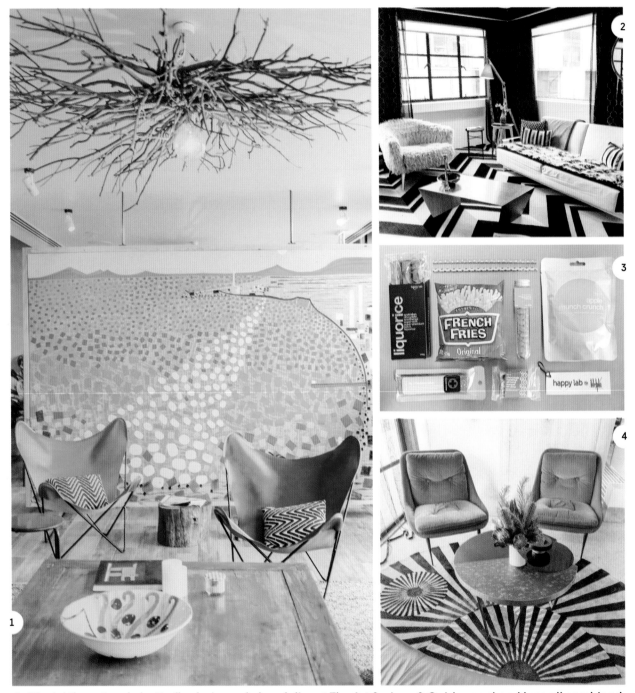

1. Diggin' the artwork, butterfly chairs and chandelier at The Art Series at Adelphi Hotel   2.Quirky, cool and luxe all combined   3. The Happy Lab loot included at Adelphi Hotel.   4. QT Melbourne design details

# CHECK-IN

## ADELPHI HOTEL

If you have an undeniable sweet tooth like me, you need to step into the world's first dessert-themed hotel. There are liquorice allsorts bar stools, cake-patterned carpets and vibrant couches with cushion covers that look like you could unwrap them and find candy inside. Each room comes with a jar full of complimentary sweet treats curated by gourmet confectionists Happy Lab, unlimited movies on offer and, if that isn't enough, I'll give you the inside scoop: house-made macarons are delivered to your room every night as part of the turndown service. A stay isn't complete without a dining experience at the famous Om Nom Kitchen, where the cocktails are quirky and the desserts are truly works of art. You'll forget that there's a whole other world out there.

adelphi.com.au

## ART SERIES HOTELS

For a tasteful art-inspired stay, a room at an Art Series Hotel will never disappoint. There are several dotted around town, and each location is dedicated to a different Australian artist, whose work is displayed throughout the interior. The Cullen in Prahran gives you easy access to one of my favourite Melbourne markets, Prahran Market, located directly across the road; The Olsen in South Yarra boasts a glass-bottomed pool and is walking distance from the shopping strip on Chapel Street; and Workspace rooms at The Larwill Studio in North Melbourne give you serene views of Royal Park, Melbourne's largest inner-city park – sometimes you'll even see hot air balloons floating past the window early in the morning. Bikes are available at each hotel and are a great way to see the city. They also provide art tours, books and utensils for a creative escape.

artserieshotels.com.au

## NOTEL MELBOURNE

Take the unique alternative with a stay in a slick 1970s Airstream caravan perched on top of a Melbourne carpark. Situated on Flinders Lane in the CBD (central business district) is Notel: part boutique hotel, part caravan park. Your temporary home offers a spacious setting with a private deck and minimalism at its best, all clean curved lines and a crisp white interior. Arrive with cameras at the ready for check-in! Oh, and in case you are wondering, yes, guests do receive free parking. The carpark is owned by Notel, after all.

notelmelbourne.com.au

OCEANIA: MELBOURNE, AUSTRALIA

## QT MELBOURNE

We all have that one friend: perfectly groomed, super stylish and always in the know when it comes to the latest fashionable happenings. If they were a hotel, they would be QT Melbourne. You'll receive a delightful welcome from the 'Director of Chaos', who is exquisitely dressed to complement the industrial-style interior filled with bespoke designer furnishings and curated modern art. And once you've checked in, the calm elegance of your room will immediately make you want to move in permanently. Ah, the #QTLife is definitely one you could get used to – oui?

qthotelsandresorts.com/melbourne

## ST. JEROME'S ROOFTOP HOTEL

The last place you would expect to find a campground is on a Melbourne city rooftop, but St. Jerome's sure does take glamping to new heights. It has tents to make your pastel dreams come true and beds equipped with electric blankets to keep those tootsies toasty during the cooler months (in case you were having second thoughts about a winter weekend stay). Not to mention breakfast – and Gelato Messina! – delivered to your tent and complimentary bowling passes with every stay. I've always been one happy glamper staying here, and I'm certain you will be, too.

stjeromesthehotel.com.au

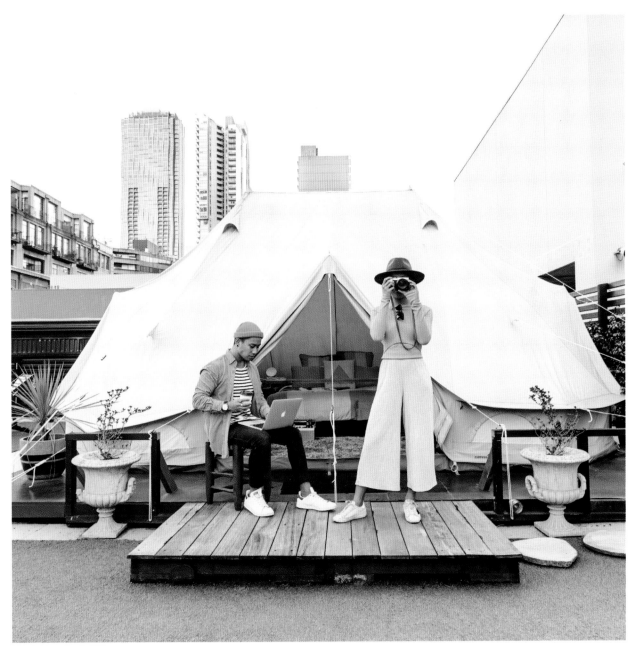

What home for the weekend looks like: St Jerome's Rooftop Hotel, Melbourne

# EAT & DRINK

## LA BELLE MIETE

This elegant specialist patisserie located on Collins Street is reminiscent of a summer romance in the City of Light. Love is in the air at La Belle Miette, which translates as 'beautiful small thing'. Here you'll find delectable desserts such as bonbons de chocolat, dragées and, I would say, *the* best macarons in Melbourne, made with pure fruit purees, premium vanilla beans and Fleur de Sel de Guérande. My top pick is the Violet & Blueberry macaron but every flavour is definitely worth a try. Plus, if you're strapped for time they even have mailable macarons: beautifully packaged in a travel-safe gift box, the macarons can be posted to most destinations in Australia.

labellemiette.com.au

## LUNE CROISSANTERIE

There's merit in focusing on one thing and doing it extremely well. Enter Lune: a bakery dedicated to croissants in a space-themed warehouse inspired by Star Wars. Now, when I say you need to get there early, I mean *early*. The main counter offers croissants and cruffins (the love child of a croissant and a muffin) that are delivered warm straight from the oven and it's not unusual for them to be sold out before lunchtime. The Lune Lab – a glass cube climate-controlled at a perfect 18°C – serves an exclusive experience that requires an online booking to enjoy a three-course pastry flight (two of which are experimental and aren't on the regular menu), along with bottomless coffee and an insider's perspective into the wonderful world of croissants. Must try: the Ham & Gruyere for savoury, any of the Twice Baked for sweet and all of the cruffins. Yassss.

lunecroissanterie.com

## PANA CHOCOLATE

Raw. Organic. Free from dairy, soy, gluten and refined sugar – and I'm talking about chocolate and cakes. Um, is this real life? Pana makes desserts you can enjoy guilt free, and its scrumptious selection with textures super smooth and silky are all handmade with love in Melbourne. They're the kinds of treats that just melt in your mouth – oh yeah! Must try: the cute Pana Pops. Then grab a takeaway mint chocolate box to save for later.

panachocolate.com

## PIDAPIPÓ GELATERIA

When you feel like eating ice-cream, you'll find Pidapipó's artisanal gelato is as smooth as it comes. Their velvety-textured seasonal flavours are handmade each day and stored in stainless steel pozzetti – the only Italian way, they say. Plus there's Nutella available for drizzling-over-your-gelato pleasure. On tap! Yep – run, don't walk ... even when you have that late-night ice-cream craving, because they're open until 11pm seven days a week. Meet you there?

pidapipo.com.au

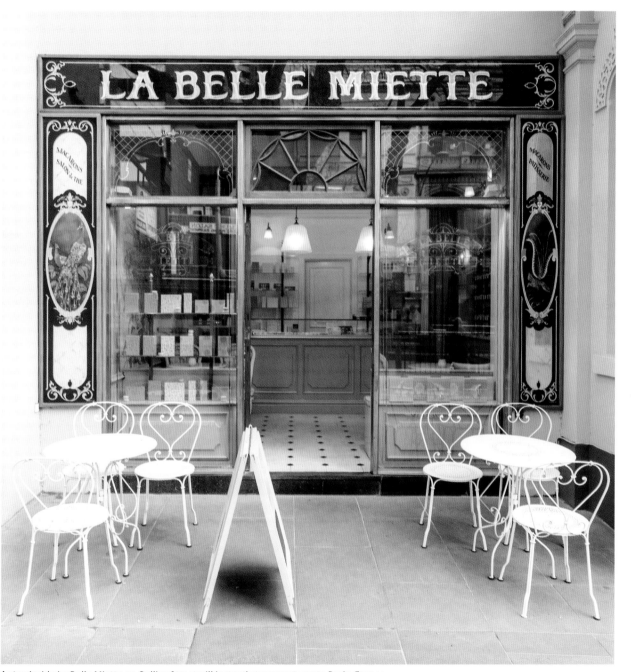

A step inside La Belle Miette on Collins Street will instantly transport you to Paris, France

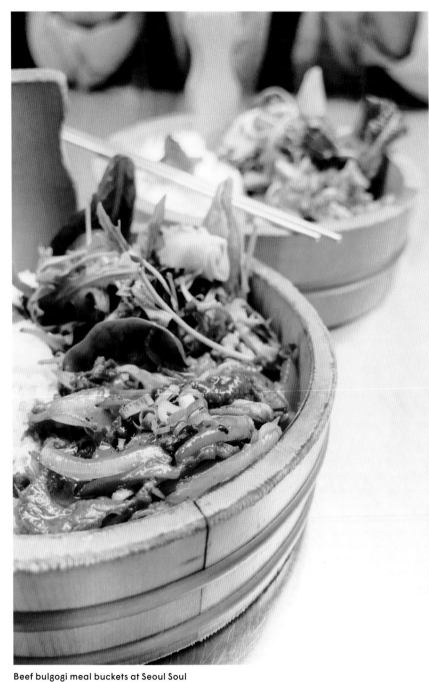

Beef bulgogi meal buckets at Seoul Soul

One of Om Nom Kitchen's signature cocktails: Girls Night Out

Flower-topped fluffy ricotta pancakes that are big enough for two

## BOMBA

Bomba is a fresh take on a Spanish workers' bar, marking a return to simple yet flavoursome tapas. Come here and either (a) sit by the bar downstairs to watch the chefs do their thing while you feast or (b) make your way up to the rooftop for an afternoon snack, a pre- or post-dinner drink or a late-night cocktail while taking in spectacular views of the Melbourne skyline.
bombabar.com.au

## DEGRAVES STREET

You'll most likely hear of this popular cobblestoned laneway because of its abundance of alfresco dining options right in the heart of the CBD. It's the perfect way to get the vibe of what the city has to offer, epitomising as it does Melbourne's famous coffee culture and street art scene. With everything from flavour-filled soups for those cold winter days to a brightly neon-signed Doughnut Time, Degraves Street is always bustling, always vibrant, and always offers plenty to taste and see.

## SMITH & DAUGHTERS

In a bluestone building on a street corner in Fitzroy is an eatery with a rock'n'roll spirit that completely scraps the perception that vegan dining is necessarily bland. Smith & Daughters offers a plant-based dining experience like no other. Many non-vegans may be surprised by how great a vegan meal can taste and that you don't even have to be vegan or like rock'n'roll to enjoy a beautiful meal here. There is also Smith & Deli nearby for convenient, tasty and kind-of-a-big-deal sandwiches that will remind you of walking into a New York deli to order a piled-high pastrami on rye. Only here, the vegan version. The smoothies are top notch, too.
smithanddaughters.com

## SEOUL SOUL

I love a good set meal, one that's cheap and cheerful in a place you know the staff are friendly and vibes are chill. I stumbled upon Seoul Soul in my first few months of living in Melbourne, and it became one of my favourite local joints. It's a Korean eatery with two locations: the cosy Richmond and the much fancier space in Northcote. Get the beef bulgogi meal bucket at either venue for about 10 bucks a pop!
seoulsoulgroup.com

## TOP PADDOCK

You may have come across photos of colourfully decorated pancakes on food blogs and Instagram when the topic is eating out in Melbourne. If you still haven't figured out where you can devour these, well then, today is your lucky day. It's located on Church Street, one of the main streets of Richmond, surrounded by mostly branded head offices and furniture stores. Remember what I said above about Melbournians and their weekend brunch rituals? I'd skip the long weekend wait that will most likely result in the inevitable hangry face, and schedule in a weekday date instead. Order the ricotta pancakes: they're generous in size (sharing is a good idea), super fluffy and have pretty edible flowers sprinkled on them. They're also available at the sister cafe in South Melbourne, The Kettle Black, which is equally as pleasant, and equally as popular.
toppaddockcafe.com

## OMBRA

Come here when you're feeling a little peckish for some cured meats and Italian wines to match. Beyond that there's the pizza: light, crisp and all kinds of delicioso. But I say ditch the menu and let the friendly staff take you on a snack safari. The space is casual vintage-chic and quite narrow but tables upstairs are perfect for an intimate dinner with a group of friends or a date night.
ombrabar.com.au

## HIGHER GROUND

They describe themselves as not quite a cafe, not quite a restaurant, and when you step into Higher Ground the interior will set the scene for a whole new dining experience – you can't help but look up! The space has 15-metre (50-foot) ceilings overflowing with beautiful natural light. Their menu showcases innovative fare for breakfast, lunch and dinner, and they also serve specialty coffee, while the wine list features varietals that range from South Africa to Spain. Head upstairs for a peek and a pic – there are great views from the second level.
highergroundmelbourne.com.au

## EVERYDAY COFFEE

This place is simplicity at its finest with a name that doesn't suggest otherwise. Everyday Coffee is one of those cafes that quickly becomes your local because of its cosy space, friendly staff and consistent serving of pleasant coffee – all day, errday. It's ideal for a morning read, quick laptop work session on the communal table or just a damn good filter coffee from a cafe that's embraced the batch brew method with a very deliberate and considered approach. Bonus hearts for the cute self-branded coffee mugs, too.
everyday-coffee.com

## MARKET LANE COFFEE

Their cups say it all, really. 'We love to make coffee for the city that loves to drink it.' With several locations around town you can cure that caffeine craving at any time of the day.
marketlane.com.au

## ST. ALI

In a backstreet of South Melbourne sits a rustic converted warehouse housing ST. ALi. It's not hard to find a great cup of coffee in this town but if you're looking for nothing short of excellence this is a place where they take their coffee very seriously, champion baristas and all. Book in for a masterclass in latte art to learn something new from the best in the biz. I learnt so much in one session, which was as fun as it was informative. Even if you can't create latte art like the masters do, you can always call it abstract (duh). Then enjoy the fruits of your labour.
stali.com.au

Coffee culture in Melbourne is strong

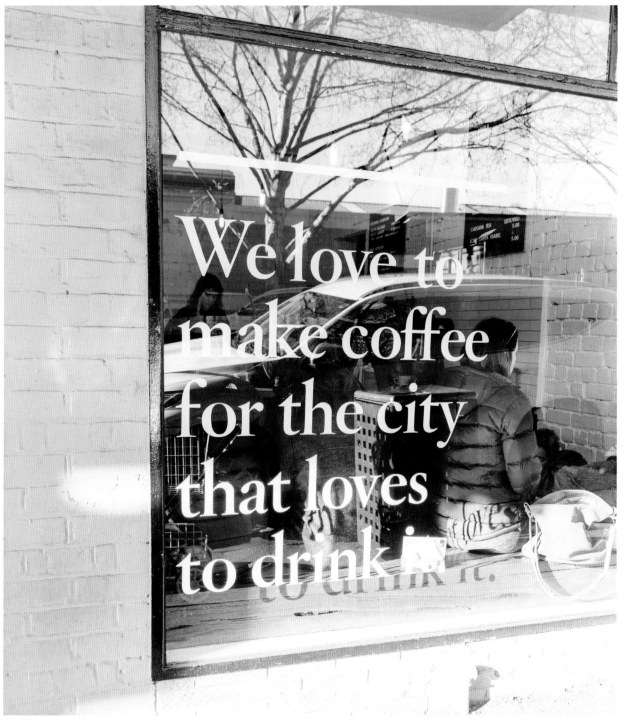

We love to make coffee for the city that loves to drink it.

Sleek and minimal chic in Melbourne

# SHOP

Foodie adventurers, set aside a few hours and flock to Queen Victoria Market (*see* p. 181). For retail precincts, make your way to The Strand (thestrandmelbourne.com) for international brands like COS, Rag & Bone and Acne Studios, and Melbourne Central (melbournecentral.com.au) and Emporium (emporiummelbourne.com. au) for leading designers, plus the latter's aesthetically pleasing food court.

## COLLINS STREET, MELBOURNE

One of the CBD's main thoroughfares, Collins Street is home to two worlds: the western end, colloquially known as the New York End, is where you'll find modern skyscrapers, banks and insurance companies in the city's financial district; and the eastern 'Paris End' is filled with heritage buildings, prestigious boutiques, high-end retailers and alfresco dining options. Head to the Paris End for the best shopping.
collinsstreet.com.au

## CHAPEL STREET, SOUTH YARRA

Follow the Lovers Walk from South Yarra railway station and you'll end up on Chapel Street, the main street of the affluent suburb of South Yarra that's home to stores belonging to Australian designers like Sass & Bide, Zimmermann and Aje. Then travel down to the Chapel Street Bazaar in Prahran for vintage shopping and a quick afternoon pick-me-up at one of the cool cafes nearby.
chapelstreet.com.au

## SMITH STREET, COLLINGWOOD

On the north side of town start your shopping on Smith Street, just a few minutes from the city on the number 86 tram. The street is the border between the suburbs of Fitzroy and Collingwood, and it's the place for vintage everything. As you wander along you'll come across an eclectic mix of boutiques, factory outlets, boho cafes and hole-in-the-walls. Keep an eye out for Smith Street Bazaar if you're keen for interior and art inspiration, Vintage Garage for vintage clothing and accessories, and Happy Valley for stationery, books and gifts.
smithstreetlife.com.au

# DO

- → Add a little fun to your fingertips and get your nails done at Trophy Wife (trophywife.com.au), a nail salon that's far from typical. It's overflowing with beautiful greenery and foliage, and has an interior that's oh-so-Scandi and girls in the cutest get-ups who prettify your nails with your requested design while tunes play. Be prepared to leave with nail art that will be a conversation starter.

- → Spend a beautiful morning bayside snapping a few photos in front of the vibrant Brighton Beach bathing boxes (brightonbathingbox.org.au). Make sure to check the weather forecast first, though!

- → Catch cult classics and new release films under the stars and over a drink at Curtin House's Rooftop Cinema (rooftopcinema.com.au), open December to April.

- → Don't miss out on exhibitions of international artists at the National Gallery of Victoria on St Kilda Road and Australian artists at the gallery's Ian Potter Centre at Federation Square (ngv.vic.gov.au).

- → Curious to see more art? Discover the laneways scattered in and around the city that are host to an ever-changing display of works by street artists. A few notable favourites: Lucas Grogan's masterpiece on the corner of Moor and George streets in Fitzroy, painted in his signature blue and repetitive style; the floral Melbourne sign towards the end of AC/DC Lane; and Keith Haring's energy-filled figures at Collingwood Technical College on Johnston Street.

- → Take a trip out of Melbourne to explore Greater Victoria: there's the Great Ocean Road for taking in views along one of the world's most scenic coastal drives (visitgreatoceanroad.org.au); the Grampians National Park for lovers of hiking and fairytales in the forest (visitgrampians.com.au); and the Yarra Valley for a bit of wine time – which, as we all know, always makes for a fine time (visityarravalley.com.au).

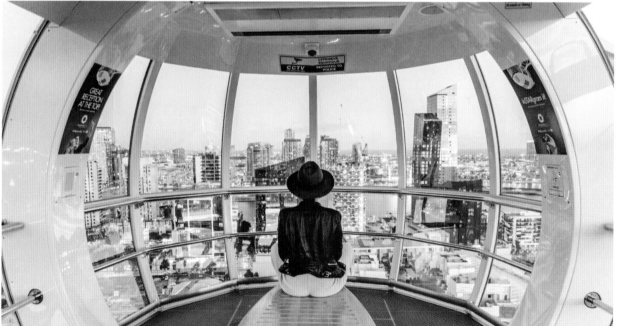

TOP Cute and colourful Brighton bathing boxes in Melbourne, Australia
BOTTOM Dusk views of the city from a private pod on the Melbourne Star

## TRAVEL TIPS

Pack and dress in layers. Melbourne's known for its variable weather, and dressing in layers makes it easy to add a layer or de-layer according to the temperature. If you want to be super prepared, pack a small umbrella in your daypack, too. It's not unusual for it to rain now and then.

Purchase a myki card to use on public transport around the city. There is a free tram zone in the CBD within which you can hop on and off free of charge.

If you're driving in the city be sure to wait behind the tram when it stops to pick up and let off passengers. Only overtake moving trams. Also, try not to get too freaked out about the hook turn; you're essentially just making a right-hand turn from the left lane. All you need to do is wait in the left lane within the intersection to let the traffic flow past, and when the lights change to green in the direction you're turning, complete the right-hand turn. Easy!

**Meet me in Melbourne**

# PACK

Expect four seasons in one day in Melbourne – it's a destination that will start with sunshine, be smothered by wind, then perhaps have rain for a few hours in between. Typical Melbourne days require dressing smart in layers, and dressing smart in layers well. Achieve this by keeping your looks casual, preppy and a little bit bohemian, all in one. It's a city filled with open-minded locals which makes expressing yourself through style an interesting experiment. If all else fails, go for the minimalist look and just wear black (as previously mentioned).

When in doubt, an all-black #OOTD will always make you look like a local

# EUROPE:
# BARCELONA // SPAIN

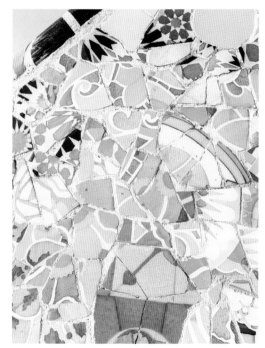

TOP LEFT Intricate tiling at Park Güell
TOP RIGHT An abundance of sweets at
La Boqueria
BOTTOM Barcelona buildings

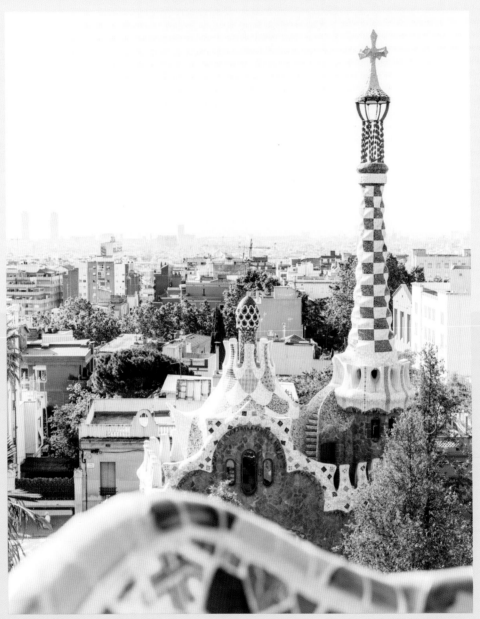

City views from the top of Park Güell

There are many reasons why the cultured and cosmopolitan city of Barcelona is one of the world's most beloved. Among them are its plethora of Art Nouveau architecture and medieval alleyways, its vibrant beaches and a wild nightlife that doesn't even start until 2am. Not to mention the unique tradition of Catalan cuisine: savoury tapas, jamón (cured ham), mouth-watering churros and sweet, sweet sangria.

And then, of course, there is the inspirational art for which the city is famous: works by the creative geniuses Antoni Gaudí, Pablo Picasso and Salvador Dalí create a cityscape and spirit like no other.

The second-largest city in Spain makes its way onto plenty of European travel itineraries, and it's easy to understand why it's so popular. The laid-back spirit of Cataluña lingers throughout its capital with long lunches, afternoon siestas and great Mediterranean weather – Barcelona was made for the good life.

# CHECK-IN

## CASA BONAY

They say two heads are better than one, so when a collective of creative minds from Barcelona collaborates on a project, you know it's going to be good. To call Casa Bonay just a hotel wouldn't be doing this exquisite establishment any justice – there's a restaurant, cafe, juice bar, 24-hour shop and cocktail bar on-site, each inspired by the diversity of Mediterranean culture. The Neoclassical building, dating from 1869 and fully restored from its floors to its ceilings, is located in the heart of Barcelona in the Eixample (Catalan for 'expansion') district. It's a 15-minute walk to top tourist destinations like the iconic cathedral La Sagrada Família and the historic Gothic and artsy El Born city quarters, and there are also local markets and beautiful parks nearby. Yoga mats, movies streamed through MUBI and free in-room wi-fi are all included in your stay, along with breakfast served at Libertine, their incredible lobby restaurant, and single-origin coffee from Satan's Coffee Corner (*see* p. 95) next door.
casabonay.com

## HOTEL BRUMMELL

Places like Hotel Brummell easily make their way into my heart – offbeat, away from the busy city centre, super stylish and with a lot of soul. This eco-friendly 20-room urban oasis makes for an inspirational stay in El Poble-Sec in the Sants-Montjuïc district. It's in a less touristy neighbourhood but only a 20-minute walk from the heart of the Gothic Quarter. Created by friends, it boasts an intimate and imaginative space influenced by 'tropical modernism', its design a combination of exotic elements and Nordic style, without losing a connection to the Mediterranean location. Every little detail has been well thought-out and hand-picked. The 1870s building, furnished throughout by custom furniture, has spacious and sparklingly clean rooms, as well as communal areas, a sauna and a patio swimming pool. And on top of all this are spectacular mountain, city and sea views from the rooftop. Vending machines are located on each floor in place of room service (a rather brilliant idea), from which you can purchase things like drinks, snacks, sweets and even condoms. Pay with your room key and you're good to go! Yoga classes held in The Garage studio and gym training sessions in their well-being centre are free for guests. Bliss.
hotelbrummell.com

The exquisite establishment of Casa Bonay, outside and inside

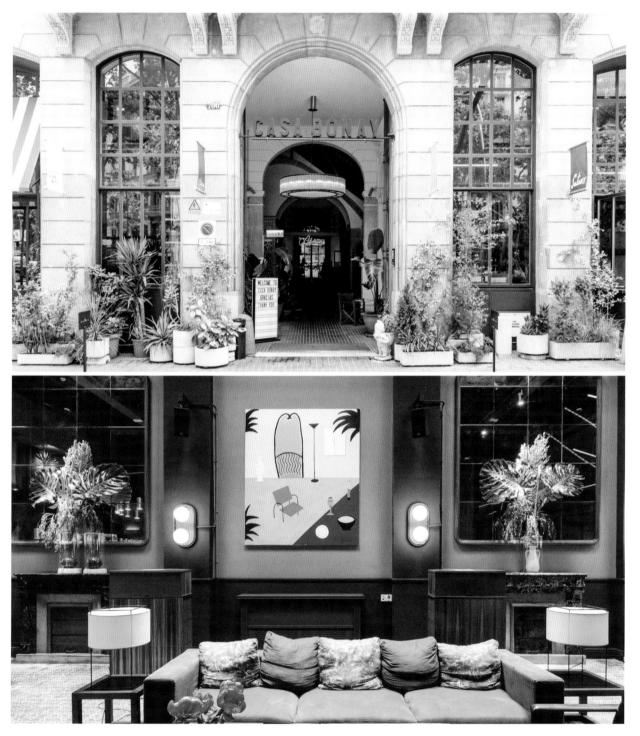

Barcelona streets

## CASA GRACIA

When you're a backpacker on a budget, finding a hostel that isn't an overcrowded and dirty nightmare can be tough sometimes. At Casa Gracia, however, what you'll experience will be worlds away from typical hostel life. Situated in Barri de Gràcia and including more than 50 rooms, it was launched in 2010 as the city's first boutique hostel. There are private as well as group rooms, a shared kitchen, a bar and a restaurant. It also has a large dining room with paintings and photographs by local artists on display, and a spacious lounge and patio where one-off events and exhibitions are occasionally held. All this within walking distance of multiple tourist attractions. Whether you're with a group of friends, coupled up or a solo traveller, there's a little something for every kind of visitor here in their minimal-chic and creatively designed space.

casagraciabcn.com

## PRAKTIK HOTELS

There's a unique theme that takes the spotlight at each location in the Spanish hotel chain Praktik Hotels. You can choose to wake up to the smell of fresh bread at Praktik Bakery, which incorporates a bakery inside the hotel; feel closer to nature at the urban oasis Praktik Garden; get a taste of Barcelona's architectural history at Praktik Rambla; and, if you're a wine lover like me, surround yourself with a world of wine at Praktik Vinoteca. All locations offer simple yet sophisticated rooms and free wi-fi, and for only €5 extra per person breakfast as well. Praktik Vinoteca is about a 5-minute walk from Passeig de Gràcia Metro station and Gaudí's famous Casa Batlló. A stay at a sophisticated hotel where the room rates are a steal and there are complimentary wine tastings several times a week? Count. Me. In. Chin-chin!

praktikhotels.com

## MARGOT HOUSE

Hotel? What hotel? If you're looking for a stay that feels more like a home away from home, then Margot House in the Eixample district is your best option. This small nine-room boutique hotel takes pride in its understated luxury, contemporary and minimal Japanese-meets-Scandi aesthetic, and personal service that make it a warm and welcoming environment. It's the brainchild of Sergio Durany and his daughter Sandra; Sergio is also the owner of Spain's eco-friendly lifestyle store Natura (*see* p. 96), while Sandra owns fashion and accessories stores BE. There's a library, free buffet-style breakfast and an in-house shop where you can purchase almost every item used in the hotel, the majority of which are local designs made by artists in Barcelona. The vibe is calm and thoughtful, housing couples and more mature travellers (no kids allowed).

margothouse.es/en

# EAT & DRINK

## BLACK REMEDY DELI AND COFFEE BAR

Black Remedy is one of those places that you pass by, then take a few steps back to look closer at what's inside. The large windows offer a good view of the modern interior, where you'll see a silhouette of a head in neon with the words 'open your mind' written inside it – that's what drew me into this place. It's a great spot to hang out if you need to squeeze in a bit of creative work on the laptop while on holiday. Their cold brew will keep you going, and if you're after an American-style smoked meat sandwich this is the place to go. Try the Roast-beef Submarine or deli-style pastrami sandwiches. Even just a fresh house-made limonada to quench your thirst in the European summer heat will not disappoint.
blackremedy.com

## FEDERAL CAFÉ

Set up by two Australians who wanted to bring the Australian cafe lifestyle to Barcelona, Federal Café has two locations: one in Sant Antoni and the other near the famous Ramblas, in a quiet part of the Gothic Quarter. This is the place to visit for a delicious brunch, especially if you're looking to sample scrumptious Australian cafe fare in between feasting on paella and tapas. They have avocado on rye toast, poached free-range eggs and lovely-tasting lattes all on the menu. Designer magazines, flower arrangements and exposed brick walls are nice features, and the large communal tables mean it's a great work space, too.
federalcafe.es/barcelona

## GRANJA PETITBO

This cute corner cafe caught my eye on the day I arrived in Barcelona. I was in a cab passing through the Eixample district on my way from the airport to my hotel when I spotted the bold white letters of Granja Petitbo's sign from the backseat window, and knew I had to visit. It's a cosy space with a rustic old-school vibe, where they play reggae tunes and serve up organic and healthy meals. They offer €12 dishes on a menu that changes daily and make fresh juices, salads, cakes and sandwiches. Really great coffee as well. Oh, and they have Nutella croissants (drool). They don't accept reservations, so I recommend going in early for brunch, especially on the weekends. Alternatively, be prepared to play the waiting game.
granjapetitbo.com

## LA ESQUINA

La Esquina's artisanal cuisine uses only seasonal ingredients, but always with a very special 'Brit' touch (the head chef hails from the UK). Open for breakfast and lunch every day, and dinner Thursday to Saturday, it's a place suitable for a wide array of occasions – from an afternoon coffee catch-up to a leisurely lunch or boozy brunch on the weekend. You'll find that the cocktails are as good as the coffee here, and there are plenty of house-made items that make an appearance on the menu. There are house-made pickles, cakes – even house-made Nutella. It's a unique and charming restaurant in the heart of Barcelona's city centre, where you can appreciate that every little detail is made with love.
laesquinabarcelona.com

Living the latte life at
Granja Petitbo

Coffee stops in the Gothic Quarter

Always love peeping the typography on cafes' espresso cups

A top working-cafe space – Federal Café

Must try: xurros de Nutella for €2

## LA BOQUERIA

Drop in to La Boqueria at least once (preferably more). This large and popular food market in the Ciudad Vieja district attracts a lot of tourists but don't let this put you off. When you enter you'll be welcomed by a rainbow of tropical fruit and fresh juices; as you walk a little further there'll be an astonishing number of food stalls selling mouth-watering chocolates, copious amounts of colourful candy and just about every food under the sun. There are also places to sit and feast on a range of local delicacies. (*See* p. 172, for further details.) boqueria.info

## NØMAD COFFEE LAB & SHOP

Best iced latte. Full stop. nomadcoffee.es/en

## SATAN'S COFFEE CORNER

Head here for a coffee and cookie break while you're out wandering. The interior is as hipster as it gets – for example, the plastic on the espresso machine has been removed so you can see its insides. Even though the name may come as a bit of a shock to some, they do make a pretty great cup o' coffee. One location in the Gothic Quarter. One in Eixample. Both with the same punk kinda spirit. satanscoffee.com

## XURRERIA

Churros – xurros in Catalan – are Spain's answer to doughnuts. The dough is piped through a star-shaped nozzle and deep-fried. Xurreria is *the* place to get them in the city: they're very crispy, not at all oily and seriously the best I tasted. Blink and you might miss it, though! It's a narrow takeaway place, located on Carrer dels Banys Nous, 8, in the Gothic Quarter, that's open 7am–8.15pm (note that they are closed 1.30–3.30pm because you know, it's siesta time!) Must try: Xurros de Nutella for €2. And they don't skimp on the Nutella (you may have guessed by now this nut spread is my weakness). Muy deliciosa!

# SHOP

### ESE O ESE

There's a natural elegance about ese O ese, a Spanish brand born in Barcelona during the 1990s. All of their stores around town have a rustic aura, and their clothing collections convey a casual free-spirited charm through visual styling that contains vintage elements. You're sure to find two things in each ese O ese piece: comfort and quality. The premise of the brand is a focus on the natural – wearable designs for day-to-day comfort, made from soft fabrics and colours. Delicate prints give a subtle boho touch and create a relaxed and romantic collection.
eseoese.com

### MERCAT ALTERNATIU PER A JOVES

With a name that translates as 'The Alternative Market for Young People', this is a second-hand market that's best described as a mecca for any good vintage clothes–wearing hipster. You can also buy one-off clothing designs, tapas and tattoos, books and comics here. It's located in lively Raval and open every Saturday 11am–8.30pm.

### NATURA

If there was one Spanish chain about which I could say I discovered and fell in love with something new every time I visited, it would have to be the eco-friendly fashion and lifestyle store called Natura. It is definitely my favourite shop in Barcelona, and I have spent plenty of euros there during my time in the city. It's got the hippie-chic feel, and the quality of materials used in their products is second to none.
naturaselection.com/en

### PALO ALTO MARKET

Palo Alto Market is held on the first weekend of every month (except August), 11am–9pm. Located just a few blocks back from the beach, here you'll be able to sample the local food, and browse design wares and clothing as well as art. It's worth strolling through – with an ice-cream in hand – even if you're not looking to take anything home. Entry is €4.
paloaltomarket.com

### PASSEIG DE GRÀCIA

If your taste in shopping leans towards luxury and high-street brands, make your way over to Passeig de Gràcia. Along this avenue you'll find a wide range of luxury labels such as Louis Vuitton, Prada and Valentino, and the coolest high-street brands like COS and & Other Stories from the same Swedish house. There are, of course, Spanish fashion chains Zara and Mango, too. Also look out for Bimba y Lola for clothing, shoes and accessories, and Oysho for beautiful swim, lounge and resort wear.
barcelonapaseodegracia.com/en

## BARRI GÒTHIC

In the beautiful neighbourhood known as the Barri Gòtic– the Gothic Quarter – the grand and mysterious alleyways will make you want to linger. Apart from the charming plaças (squares), there's an abundance of shops to explore, from the more commercial area of Calle Portal de l'Àngel to the little boutiques on Calle Avinyó. Here are a few to keep an eye out for.

**LA MANUAL ALPARGATERA:** Espadrilles are the ultimate European summer shoe and a must-buy when you're in Spain. La Manual Alpargatera, whose workshop is behind the store, has been making espadrilles for almost a century and is a leader in this handicraft. Go for a classic tie-up pair and ask an attendant to show you how to lace them up properly. lamanualalpargatera.es

**L'ARCA:** Romance is in the air at L'Arca (formerly known as L'Arca de l'Avia). It's a gorgeous vintage dress shop around the corner from Oliver (*see* right), and it's where Kate Winslet's evening gown from *Titanic* was created. They stock an incredible selection of antique bridal wear, especially ball gowns, as well as high-end vintage fashion from the early 20th century oozing other-worldly elegance, including accessories such as lace gloves and jewellery. You'll also find Japanese kimonos and chic hats and handbags from luxury designers like Chanel, Hermès and Dior. If you have any special occasions on the calendar, you could purchase an amazing souvenir here. larca.es

**LOVE VINTAGE:** Vintage lovers, this one's for you. Their black-and-white sign on Carrer de Bertrellans is hard to miss. Open since April 2011, Love Vintage offers new stock every week: arriving Monday morning, by the afternoon it's ready for you to shop from the rails. Most of the clothing is from the 1970s to 1990s, but there's also some that's a little older as well as new band tees. The owners occasionally display pieces they have made themselves, too. lovevintage.es/en

**OLIVER:** It's described as a store that stocks 'decoration for your home' but these are not the only things you'll find at Oliver. You'll be drawn in by the enchanting chandelier and led by fairy lights first to a wide selection of clothing and accessories with an effortless bohemian twist, and then on to furniture, homewares and rugs as you reach the back. It's a super dreamy store to get lost in and pick up a few little pieces from just about any category. worldsoliver.net

# DO

→ If anyone is responsible for shaping the aesthetic of Barcelona, it's Spain's architectural genius Antoni Gaudí. His wondrous works around the city are absolute must-sees. They include the multi-level Casa Batlló (casabatllo.es/en); the incredible mosaic tile-work at Park Güell (from which there are also stunning city views – parkguell.es); and La Sagrada Família, a cathedral that has been under construction since 1882 and which, although incomplete, is a UNESCO World Heritage Site (sagradafamilia.org).

→ Get an insight into Spanish painter Pablo Picasso's life at the Picasso Museum (museupicasso.bcn.cat). Find out more about Picasso's approach to art, get lost in his most famous pieces and be taken back in time inside the beautiful courtyard. Schedule a visit on any Sunday after 3pm or the first Sunday of each month to enjoy free admission.

→ Take a dip in the waters of the Mediterranean. What trip to Barcelona would be complete without a day out at the beach in the European summer? Relax, people watch, cruise along on a bike or join locals in a game of volleyball. Then enjoy a boozy lunch right by the water. Life's good!

→ Have an afternoon siesta. Siesta: a short nap taken in the early afternoon (approximately 2pm–5pm), after the midday meal.

→ Indulge in a Spanish feast of hot paella (seafood is always my number one choice), small scrumptious share plates (referred to as tapas), and of course ¡salud! over a jug of sangria, the national drink of Spain.

→ Go on a DIY tapas tour: just like bar-hopping, except with tapas instead. Treat your tastebuds to variety and make your way through multiple locations and many flavours on the main strip of La Rambla.

→ Put on those heels, let your hair down (or guys, don a nice shirt) and go out for a night of dancing at Sala Apolo.

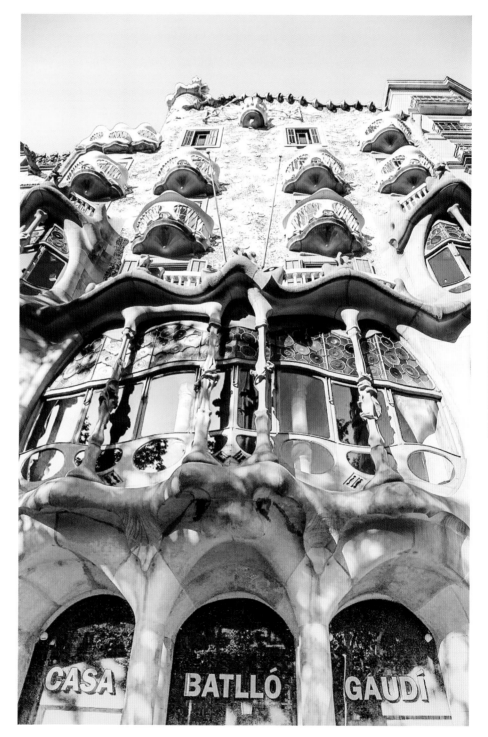

Another one of Gaudí's
architectural masterpieces

## TRAVEL TIPS

It's traditional in Spain to eat a big meal at lunch and a smaller meal for dinner, so make sure you've worked up an appetite by midday to fully enjoy the Spanish way of eating.

Many stores close 2pm–5pm for lunchtime siesta, as well as on Sundays and public holidays. Bars and restaurants can close any time from about 4pm until about 9pm. Time your shopping and foodie outings accordingly.

Crowded places such as La Rambla are where pickpockets are most likely to strike. Be aware and keep your personal belongings close to avoid being a target.

# PACK

Barcelona's bohemian energy is infectious, its medieval alleyways are mysterious and its people are full of life. Keep your look free-spirited and effortless to blend in with the locals and pack pieces that are casual and comfortable.

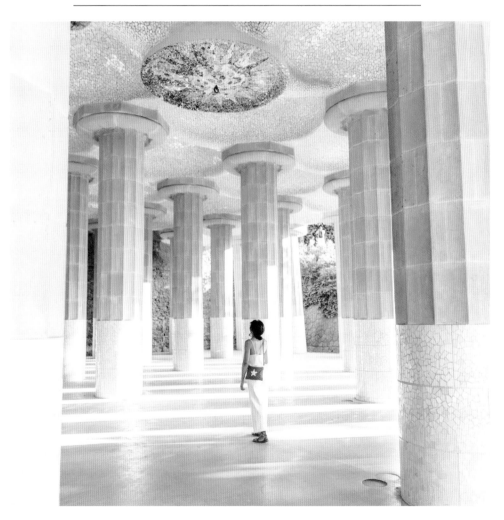

OPPOSITE Gracias for the good times, Barcelona
ABOVE In absolute awe looking up at Park Güell

# SOUTH AMERICA: CARTAGENA // COLOMBIA

TOP LEFT Flavourful selection at
La Paleterria
TOP RIGHT AND BOTTOM LEFT The art-filled
Getsemani neighbourhood
BOTTOM RIGHT Inside the stone-walled city

My first solo travels around South America included Colombia. This was a trip I took purely for pleasure – no work commitments, no complimentary stays to review and zero travel plans. The highlight? The queen of the Caribbean coast: Cartagena.

Cartagena's old colonial town is a UNESCO World Heritage Site – surrounded by a stone wall more than 500 years old are brightly painted multicoloured buildings with balconies draped in bougainvillea, a maze of cobbled streets and the upbeat rhythm of the Colombian culture found around every corner.

It's a destination that's truly a walking city, easily and best explored on foot; you can stroll through the vibrant streets steeped in history and culture, be immersed in the sensual atmosphere, and stop by one of the city's open-air cafes for a fruit-flavoured paleta (popsicle) or two. The collection of 27 coral reef islands off the coast of Cartagena are hidden gems, and beautiful beaches are only a short boat ride away from the city. And when night falls, there's nothing better to do than dance – salsa or bachata at the clubs, champeta on the streets or zumba classes that locals hold in outdoor public plazas.

Partners not required. High energy an essential.

You know the Colombians: they very well know how to dance and love doing it.

# CHECK-IN

## CASA LOLA

Just outside the walls of Cartagena's historic Old Town is the neighbourhood of Getsemani, once a haven of prostitution and drugs. Like many of Cartagena's neighbourhoods with complicated and story-filled pasts, Getsemani is emerging as an invigorating and artfully tasteful neighbourhood. It's authentic despite being gentrified, and offers a little more grit than the streets inside the city's walls. It was a delight to stumble upon the gem that is Casa Lola: a ten-room boutique hotel set in two 17th- and 19th-century colonial buildings. It's chic, homely and has furniture sourced from all around the world. There are plenty of necessities within reach, like cute cafes, restaurants, bars and a grocery store – it's even on the same strip as the popular bar Havana (*see* p. 110), so it's easy to get back to your home away from home after late nights of salsa dancing. There's also a rooftop pool for some mucho relaxo time. In Cartagena's heat you'll never regret accommodation that has a pool.

casalola.com

## CASA SAN AGUSTIN

Old Town is the most touristy part of the city but if you want to be close to everything this is the area for you. There's always that one ultimate place to stay in a destination and for Cartagena, Casa San Agustin is, hands down, *that* place. It's nothing short of luxury chic, with a colonial heritage and architecture evoking the city's rich 17th-century history, all within three beautiful whitewashed houses containing twenty guest rooms and ten suites. The hotel is also just a few steps away from Casa Chiqui (*see* p. 114), one of my favourite boutiques and places to shop in Cartagena. Dangerous or fortunate? You decide.

hotelcasasanagustin.com

PREVIOUS Colombia's colourful streets
OPPOSITE Looking down from the top of Casa Lola

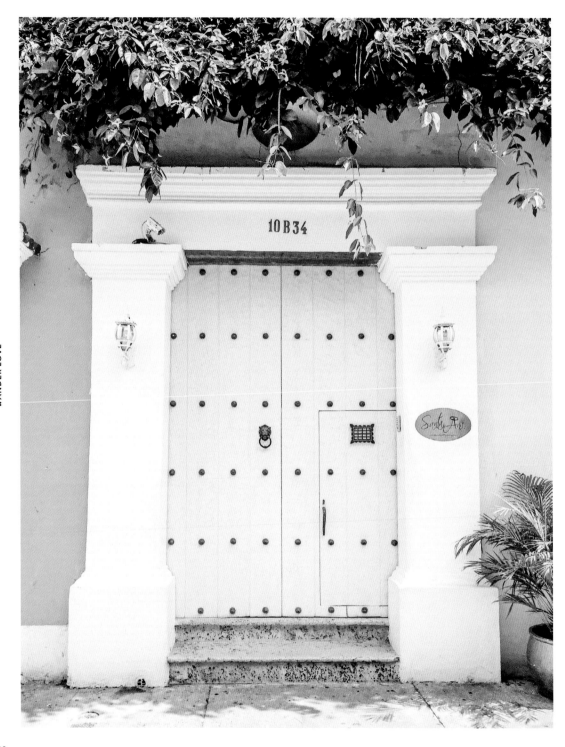

## HOSTEL PAPAYA

A couple of blocks down from Casa Lola, Hostel Papaya is a more social and budget-friendly option in the heart of the artistic jewel that is the Getsemani neighbourhood. It attracts a great crowd: fewer rowdy party types and more mature explorers who still like to have fun. The rooms are clean, Colombian breakfasts are included in the room price, and there are casual communal spaces where free dance classes are held each week – a non-intimidating way to get a handle on those champeta moves. Right out the front of the hostel is the main square where lots of locals hang, occasionally holding spontaneous and lively zumba classes, and where stands serving delicious Colombian street food set up shop in the evening. Make sure to try the arepas! These are a traditional snack of corn cakes filled with different stuffings like carnitas (meats) or queso (cheese) and are a daily staple in Colombia. Delicioso, too!
facebook.com/papayahostal.getsemani

## LA PASSION HOTEL

If you're looking for that perfect combination of charm, ambience and the practicality of a pool (because you'll need it to beat the hot and humid days in Cartagena – trust me), there's the exquisite eight-room boutique hotel La Passion. It's in Old Town and just around the corner from Casa San Agustin. You'll be able to soak up the incredible views from the rooftop pool, and be spoilt by the selection of cocktails, French wines, lobster and fresh fish of the day at their bar restaurant, not to mention the very attentive and pleasant staff. Breakfast is the most important meal of the day: choose from either a continental or a Caribbean breakfast. I say get the latter and have it served on the charming terrace lounge. You know how the saying goes … When in Rome, no?
lapassionhotel.com

SOUTH AMERICA: CARTAGENA, COLOMBIA

Cartagena's charming colonial architecture

# EAT & DRINK

## ÁBACO LIBROS Y CAFÉ

Despite Colombia being one of the largest coffee producers in the world, finding a decent cup of coffee in Cartagena can be tricky. Enter Ábaco Libros y Café, a quaint bookstore and cafe that is the realisation of a dream long cherished by its founder: to have a cultural place by the sea and within the history-filled walls of Cartagena. Set among bustling surrounds, Ábaco offers peace, tranquillity and solitude once you step inside. There are mountains of books to bury yourself in and, most importantly, they pour one of the best cups in town. Wi-fi is available, too.

abacolibros.com

## ALQUIMICO

You don't go to Alquimico to simply down a few shots to lift your confidence and get the night started. You go for the dynamic and (literally) smoking craft cocktails made by the best bartenders and mixologists who are as creative and 'out there' as the characters in a Tim Burton film. It's right in the heart of Old Town and resembles a Manhattan speakeasy, in a finely re-tuned warehouse space with a rooftop where lively outdoor dancing can be found on Fridays and Saturdays. Alquimico has turned drinking into a fine art in Cartagena. Must try: the Passion Tea and Salitre.

alquimico.com

## CAFÉ HAVANA

The 'world famous' Café Havana is the place to sip on a Mojito and salsa to Cuban music played by live set bands. It starts to get packed between 10 and 11pm. Be prepared: drinks are expensive here but it's well worth a visit to experience the buzzing atmosphere and let your hair down.

cafehavanacartagena.com

## CAFFÉ LUNÁTICO

With the owners a couple hailing from Cartagena (her) and Cataluña (him), Caffé Lunático promises a unique culinary experience for the tastebuds. It's a top pick for brunch – or lunch – with its relaxed atmosphere, fresh locally sourced ingredients and affordable prices for such high quality food. Weekdays are perfect for a casual coffee (preferably frio, Spanish for 'cold') or mimosas if that's your thing, and reservations are recommended for weekends as they can get quite busy. They also occasionally hold impromptu events. Must try: their tapas selection, served from 11am to 11pm. Order a jug of sangria while you're at it and salud to the weekend with friends!

Put those dancing shoes on and put them to good use at Café Havana

## DEMENTE

There's a hipster hot spot that I favour for a night out in the neighbourhood of Getsemani. It's dimly lit, serves top tapas and artisanal pizzas, plays eclectic grooves that mix swiftly from funk, blues and Frank Sinatra to flapper jazz, reggae and Ray Charles, and has a good-looking crowd of locals and cultured out-of-towners. The quirky decor will make any art appreciator feel right at home, such as hand-painted plates with quotes from Colombian poet Raúl Gómez Jattin and bottle caps used as business cards. Nights start young at 9pm; if you're travelling solo perch at the bar for a charming chat or if you find yourself there with friends sip on Demente's quality mix of cocktails while swaying in the aluminium rocking chairs that take the place of standard ol' chairs.
facebook.com/demente.com.co/

## LA CEVICHERIA

When you hear good things about a restaurant from almost everyone, you have to check it out – and La Cevicheria is the place everyone recommends for the city's best ceviche. It's a tiny but charming, no-frills eatery in the far top corner of Old Town where seafood holds high ranks. No reservations are taken and there's *always* a line so after you put your name down on the wait list pop into the bar across the street to kill time and save your stomach, as it's worth the wait. What to order? Definitely have the ceviche de langosta (lobster), which comes in a citrusy, just-sweet-enough broth, accompanied by two packets of saltine crackers on the side. Tip: take a seat at one of the outdoor tables for an alfresco lunch complemented by some people watching.
lacevicheriacartagena.com/en

## LA PALETTERIA

In case I haven't made it clear yet, temperatures in Cartagena soar. They're the kind that require a generous amount of hydration, breathable fabrics and multiple cold showers a day to feel fresh. Paletas are always a good idea for a pit stop in between your wanderings. For an abundance of flavour selections pop into La Paletteria and take your pick. Consume it at your leisure inside the store or be prepared to eat it super quickly if you step outside. You don't want it melting all over your hands, a messy lesson I learnt the first time round! These paletas will save the day after long hours of walking, or try limonada de cocos (coconut water lemonade) from the street carts – also a great way to cool down.
lapaletteria.co/en

Paletta flavour of the day: bubble gum

# SHOP

I find most satisfaction in shopping from Cartagena's street vendors, strolling past almost every day and stopping by to practise my Spanish with the local sellers, who speak with a warm, Caribbean coast accent, then continuing on to classe de baile (dance classes). You'll find plenty of stalls around every corner of the city's colourful streets, selling goods such as panama hats, handmade bucket bags, wooden maracas and pompom anything and everything! There's also a handful of boutiques that are a delight. Here are my favourites.

## CASA CHIQUI

Imagine this: you're walking the vibrant streets of Cartagena on a warm afternoon and stumble upon a kind of treasure trove. Unlike the markets, there are treasures to be found here but less scouring to do – everything is chic, from the furniture and homewares to the apparel and fashion accessories. The items in the store, bursting with colour and diversity, contrast with the black-and-white check pattern of the floor.

There are designs from all corners of the globe – Colombia, Mexico, Indonesia, India, Morocco – and even exclusive ranges of jewellery and accessories produced in collaboration with international designers and indigenous tribes. This is *the* retail go-to destination in town, and there's magic to be found here.

casachiqui.com

## LAS BÓVEDAS

Located in a venue originally built as bombproof dungeons used for storage of munitions and later as prison cells, Las Bóvedas (Spanish for 'the vaults') is now perhaps the most famous of Cartagena's markets. Selling traditional Colombian clothing, handicrafts, jewellery and paintings, it's a one-stop shop for a vast array of souvenirs. You can't miss it, with its buzzing atmosphere and big, bright yellow walls, right by the sea.

## ST DOM'S

St Dom's carefully curated collection of cutting-edge Colombian designers makes shopping for local luxury gifts for loved ones – or yourself – in Cartagena all too easy. You'll find high-end fashion, art, books, jewellery and homewares in a spacious and stylish fit-out in Cartagena's first concept store and designer destination. Think of it like this: Paris has Colette, New York has Opening Ceremony and Cartagena has St Dom's. It's white, bright and has all the things I like! Most of all, they keep things fresh and fun.

stdom.co

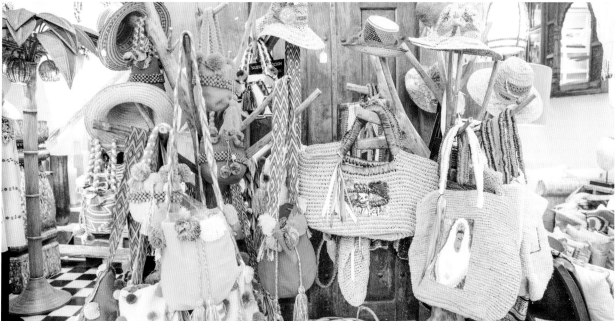

TOP Retail therapy at St Dom's concept store
BOTTOM Colourful displays at Casa Chiqui

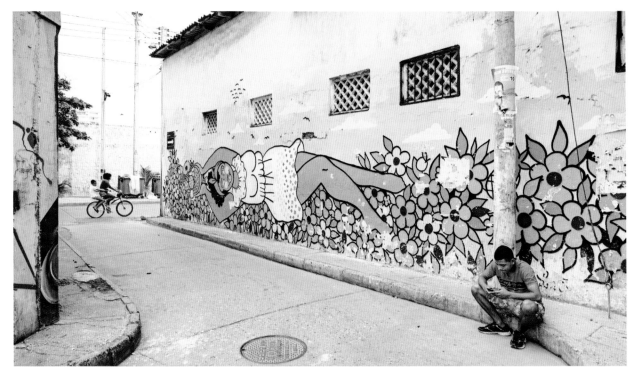

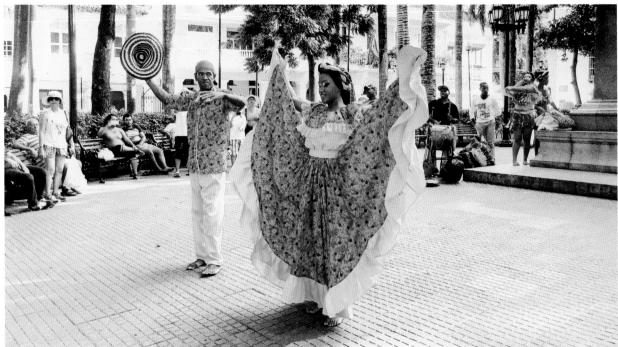

# DO

→ Book in to attend dance classes: salsa, cumbia, bachata or the dance local to Cartagena called champeta. It's a style of folk music and dance that originated from the communities of African descent along the Atlantic coast. New grooves are always a special souvenir to take away from your Colombian travels. Check with your casa: most accommodation will hold free classes or can most definitely recommend a place. I have attended numerous clases de bailes at Crazy Salsa (crazysalsa.net) in the heart of Cartagena, which is always a pleasant experience.

→ Take a day trip to Rosario Islands. One thing that they don't mention is that the swell is pretty strong on the way to the islands but once you arrive it's all worth it. If you're also a lover of snorkelling it's decent here, and the grilled fish is super scrumptious.

→ Walk up to Castillo San Felipe de Barajas for the views. Don't forget your camera!

→ If you're travelling solo and a little cautious about your camera gear, book a Cartagena Photo Tour with This Is Cartagena (ticartagena.com). You'll be taken to back streets for hidden photo opportunities and photogenic corners, have a local photographer to help you communicate with locals and learn a little bit more about the culture and history behind Cartagena. The tour ends up at the walls of the Old Town at sunset, where you can take beautiful silhouetted photos.

→ The Volcano Mud Baths are a touristy experience geared more towards backpackers but rate a mention. What you should know: you can't take your own photos of yourself or your friends – you have to pay for a snap. There's one fee for phone, one for camera. Also note: there are lots of mosquitoes!

TOP Street art in Getsemani discovered whilst on a photography tour through Cartagena
BOTTOM Cumbia is a dance popular in Latin America that originally began as an expression of courtship practiced by the African population of coastal Colombia and Panama

## TRAVEL TIPS

Taxi is the best option to get from the airport into the Old Town. A trip should cost you between 9000 and 15,000 Colombian pesos and will be about a 15-minute drive.

Almost everything is within walking distance in town and in Getsemani so it's easy to get around, but there are also plenty of taxis. Ask the price before getting in and note that they accept cash only.

When dining out make sure to ask for the Menu del Dia otherwise you'll get the tourist menu that is much more expensive.

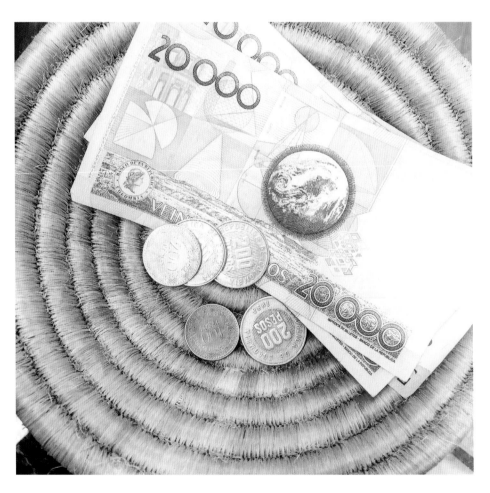

Colombian pesos

# PACK

The Latin culture normally leans in style towards the sexy side. While other Colombian cities own this, the tropical climate of Cartagena, similar to other Caribbean cities like Tulum in Mexico, gives its style a different focus. Think chic and elegant but still a little laid-back and relaxed.

Sombrero street shopping. I bought two styles, can you guess which ones?

TOP LEFT Street signs in Pueblo
(downtown Tulum)
BOTTOM LEFT AND RIGHT Lounges along
Tulum's main beach

# NORTH AMERICA: TULUM // MEXICO

I had long admired from afar the beauty of Tulum before actually making my way there, again and again. This once sleepy town on Mexico's Caribbean coast has become a kind of spiritual oasis, particularly for the likes of the fashionable crowd. It's the kind of place that naturally makes you eat healthier, sit taller and practise #yogaeverydamnday (or at least try to), just because. It's stylish and free-spirited … there's a sophisticated yet laid-back charm to this place, from the main beach road (Boca Paila) to downtown Tulum (called Pueblo by locals).

Tulum may no longer be Mexico's best-kept secret, but that won't stop you from instantly falling in love with this jungle paradise. If you're a lover of sunshine, nourishing food (Mexican es mi favorito!) and pristine beaches, it's a refreshing place to visit to unwind, relax and reset for a few days – or weeks. Just don't forget the SPF. Or the insect repellent.

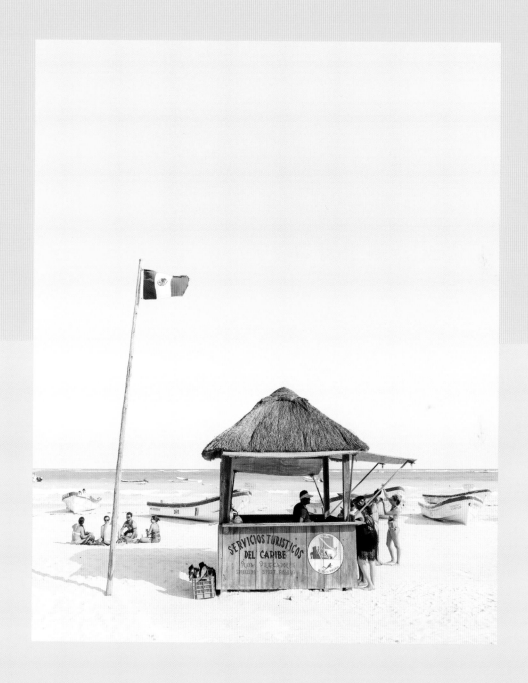

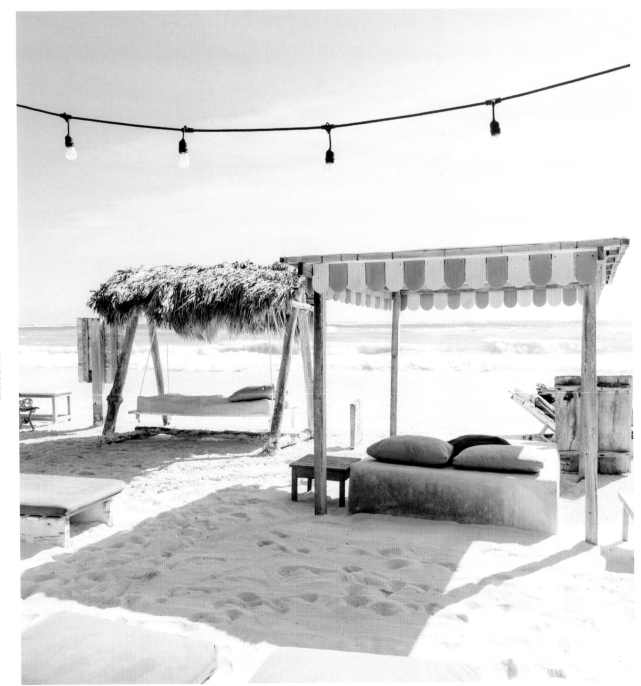

PREVIOUS The bluest waters and whitest sand I ever did see
ABOVE Just steps away from the Caribbean Sea at Coco Tulum

# CHECK-IN

## AZULIK

Azulik is truly a lovers' paradise: a romantic adults-only eco-resort with balconies and swings from which to enjoy the awe-inspiring views of Tulum's turquoise sea. It's a treehouse for grown-ups, and an unforgettable one at that. The appreciation for nature goes beyond words in this resort through its organic architecture inspired by the natural surroundings and the use of systems that ensure the resort is self-sustainable. They even have a cenote (a natural pool formed when limestone bedrock collapses exposing the groundwater beneath) on-site that provides sacred water to all rooms. Yep. One look at their Instagram and you'll be hooked, too …

azulik.com

## COCO TULUM

The old-style cabañas at Coco Tulum may just be the best-value accommodation on the beach. They're simple, spacious, clean and stylish in a rustic way. Your mornings will unfold a little something like this when you stay there: rise with the sun, stretch while walking barefoot on the white sand (you're literally only a few steps from the water), and take a refreshing dip before eating a healthy breakfast. After such a great start you will always look forward to the day ahead. If you're not a morning person I'm fairly certain this place will quickly change that.

cocotulum.com

## LOS AMIGOS

For a quieter option, Los Amigos in Tulum town is a slick and polished alternative. You'll need to catch a cab to get to and from the main beach area as it's a bit of a trek on foot, but restaurants, bars and shops on the main strip of town are close by. Get bubbly in the jacuzzi, start your day with a morning swim in the rooftop pool or head out for a ride on one of the property's bikes. It's also next door to a language school – handy if you're looking to learn a bit of Español while you're in Mexico. ¿Por qué no? (Why not?)

losamigostulum.com

## NOMADE

The boho-gypset vibe of Nomade is reminiscent of Marrakesh. There's daily yoga held in a big Bedouin tent in the AM, hanging hammocks for afternoon siestas and the decor features textiles with rustic Moroccan prints. It's a top pick right on the main beach if you want to treat yo'self or awaken the soul – they have frequent workshops about spirituality. Nomade is a spectacular creation by the team behind the hotel's equally cool neighbour next to the sea cliffs, Be Tulum, and sister wellness spa, Yäan. You'll be one happy (and well-rejuvenated) glamper, indeed.

nomadetulum.com

Fish tacos all day, 'errday

Spending my working days at Tulum Art Club and Coffee Bar

# EAT & DRINK

## BATEY MOJITO AND GUARAPO BAR

'Everyone knows Batey,' he texted. 'Just ask for the place with the VW Beetle out the front.' It's true, Batey Mojito and Guarapo Bar is widely known for the brightly painted Volkswagen Beetle parked out the front from where they serve the minty fresh cocktail with freshly crushed sugar cane on tap. This is the spot in Pueblo to go for drinks and live music. It has an awesome courtyard, tasty but low-key food and drinks and a laid-back atmosphere enjoyed by locals, expats and visitors alike.

facebook.com/bateytulum

## GITANO

The neon pink sign beaming on top of the foliage-draped entrance reflects all of the good vibes of Gitano restaurant and mezcal bar. It's a great place for dinner and dancing under the disco ball on Fridays, and for drinks accompanied by live music on Sundays. Grab a Mezcal Mule from their creative cocktail list – a bit on the pricey side but well worth it.

gitanotulum.com

## CASA JAGUAR

Casa Jaguar is the place to be when the sun sets on a Thursday and they hold their #JungleParty into the night. This sophisticated restaurant is full of lush greenery and has romantic dim lighting throughout, with a courtyard dance floor in the centre. Cocktails are a highlight – the Maria Sandia, with mezcal, watermelon and lime and finished with worm salt on the rim, was my favourite. If you're looking at dinner options, there's the catch of the day baked in their wood-fired brick oven or dishes of grilled seafood and rib eye, all served in delightfully generous portions. Within this picturesque open-air jungle setting you've got beautifully intimate spaces for two, but it is equally enjoyable in a group.

casajaguartulum.com

## FLOW

You could easily spend a whole afternoon hanging out at FLOW, an incredible vegetarian restaurant tucked away behind Harmony Glamping and Boutique Hotel in Pueblo. Dishes are made with fresh ingredients from their garden and the iced coffees will save you on the hot days you're in need of a caffeine fix (and they are really, *really* good, by the way). You should never leave here without a taste of the desserts – order the Mango Tango and feel your tastebuds dance! FLOW also has Thai nights (I'm salivating at the memory of the flavours while I type this), and swings for seats in their casual and relaxed outdoor area. I can't forget their awesome taste in tunes; you'll be Shazam-ing one after the other.

facebook.com/flowtulum

## LA POPULAR & MACONDO

Nomade hotel houses two notable eateries: La Popular, a fish market–inspired beach restaurant that believes in sustainably sourced seafood; and Macondo, which serves wholesome and holistic food intended to heal from the heart and nurture the soul. Pop into La Popular for lunch and order the catch of the day served with a marinade of your choice or tuck into the vegan and vegetarian dishes created from produce that's both natural and nutritious at Macondo.
nomadetulum.com

## HARTWOOD

If you find yourself having dinner here, lucky you – there's usually a wait for a table if you haven't made a reservation. It's quite possibly the most famous restaurant in Tulum and absolutely one not to miss! Their menu, featuring dishes made with fresh seafood and local produce, changes daily. I find it best to ask the staff for recommendations when they come over to talk through the specials board.
hartwoodtulum.com

## POSADA MARGHERITA

The juices alone at Posada Margherita will be enough to have you going back again and again. Binge on the 'heavy metal detoxifying' green juice and your skin will definitely thank you for it. But the pasta – oh, the pasta! – is something else. It's made to order from scratch and top-notch ingredients are used to create very tasty dishes – the shrimp and zucchini pasta and the freshly caught fish lightly poached in sea water are a mouthwatering delight for the tastebuds. They have a well-designed beachside set-up where you can enjoy the ocean view and while away the afternoon (and if you're looking for a place to stay, they also offer homey, apartment-style accommodation).
posadamargherita.com

TOP Pulling up to Posada Margherita
BOTTOM Eating like the locals: coconut with a splash of lime and a hint of chilli

1. Mexican and Latin American designer wares   2. Pompom hats at KM33
3. A colourful approach to the ancient huaraches, a type of Mexican sandal

# SHOP

## JOSA TULUM

Vintage-inspired, day-to-night, wrinkle-free kaftans and dresses are what you'll find at local brand Josa. The founders hail from New York and Mexico, and officially opened their first boutique on the main beach road in 2009. Every piece is a thoughtful reflection of the carefree Tulum lifestyle along with the fashionable sophistication of the New York way of life.

josatulum.com

## KM33

Pump the brakes on your bike when you spot the colourful pompoms! You've found KM33: a one-of-a-kind boutique combining the best in Mexican and Latin American designers. It's a treehouse-inspired space which you'll find between Hartwood restaurant (*see* p. 128) and Sanará Hotel. There are lots of straw hats, hand-painted baskets, fun exotic jewellery and colourful pompom accessories to get excited about.

km33tulum.com

## LA TROUPE

La Troupe is hard to miss – it's housed in a shipping container on Boca Paila. Its well-edited selection of Mexican designer clothing, accessories and homewares will give you the key ingredients of the free-spirited Tulum uniform. There are flowy kaftans, gold accent jewellery and a mix of embroidered textiles.

latroupe.com.mx

## LOL TULUM BOUTIQUE

Just before you reach the restaurant area at Posada Margherita (*see* p. 128) there is a cosy beach boutique on the right. You'll be drawn in by the beautiful curation of bikinis hanging out front, and inside is a pleasant assortment of luxurious quality brands by small designers from Mexico and the US. It's a tiny space, but one that you should definitely hunt down to have a peek.

posadamargherita.com

## WANDERLUST

There's a pebble-lined side street off Boca Paila that leads to a sweet shopping spot called La Placita (The Little Plaza). Here lies Wanderlust, which stocks all of the items needed for you to nail the effortless chic of the Tulum look. You'll find a wonderful selection of light cover-ups, straw hats, leather sandals and jewellery, as well as my favourite: the organic cotton low-back dresses that are designed to be worn in more ways than one. Look for its hand-painted sign propped on the ground outside the entrance.

instagram.com/wanderlustulum

# DO

- → Swim through cenotes. There are more than 7000 cenotes on Mexico's Yucatán Peninsula! Must visit: Cenote Ik-Kil (Sacred Blue), with waterfalls and lush green hanging vegetation, and Cenote Dos Ojos (Two Eyes), which is two cenotes linked by a large cavern. Explore on your own to find a few magical others.

- → Float through Sian Ka'an National Park, a UNESCO World Heritage–listed site encompassing mangroves, forest and a marine section with a barrier reef (visitsiankaan.com).

- → Keep up your practice (or try something new!) at Sanará Yoga Studio (sanaratulum.com). Sanará means 'you will heal' in Spanish and the studio overlooks the turquoise waters of Tulum beach.

- → Take a Sunday night salsa class at La Zebra (lazebratulum.com) for a little barefoot fun on the beach.

- → Develop new language skills and learn Español. Meztli (meztli.mx) is a school in Tulum town that offers language classes together with free activities such as cooking classes and yoga and salsa lessons, as well as group excursions you can join for an extra fee.

- → Treat yourself at Mayan Clay Spa (mayanclayspa. com) by spending a blissful hour having a full body oil massage and Mayan clay face mask. It'll do wonders for your skin and leave you feeling relaxed and rejuvenated. A pamper session is *always* a good idea.

- → Witness breathtaking views of Tulum's beautiful aqua ocean from Ruinas Mayas de Tulum, the ruins of a Mayan walled city perched precariously on the edge of a cliff. Travel tip: Wear your bathers and take the stairs down to the beach below the ruins. It's open 8am–5pm and access costs 40 pesos per person.

- → Get your contemporary art fix at the stunning Casa Malca. Originally owned by Pablo Escobar, the infamous Colombian drug lord of the 1980s, the mansion is now a boutique hotel and art gallery.

- → Book a day trip to Akumal. It's about half an hour by car from Tulum and is the place to snorkel and swim with green sea turtles in the wild.

Floating through Cenote Dos Ojos

## TRAVEL TIPS

Restaurants and nightlife in Tulum are mostly open-air and in the jungle – keep the mosquitoes away by always carrying bug repellent.

Most eateries and shops accept cash only. You can pay in either Mexican pesos or US dollars, but the exchange rate means you'll get a better deal if you pay in pesos. There are plenty of ATMs around – just make sure whichever you choose will give you the local currency before you use it.

If you're hiring a bike, try to round up a group as well as rent for longer periods of time to get a discounted rate.

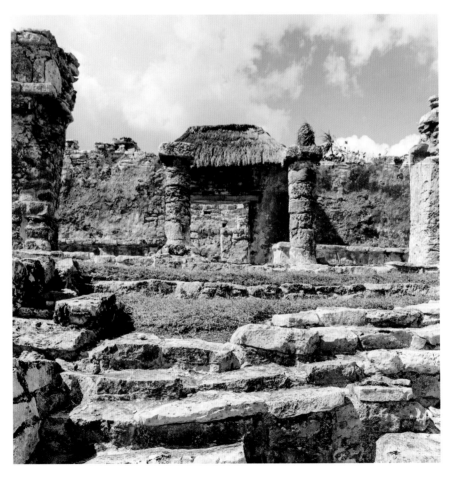

A walk way back in time at Ruinas Mayas de Tulum

# PACK

The vibe for girls is effortless wavy hair (or low slick buns), flowy dresses (bra optional) and a natural bronzed glow (always). Guys should keep their style relaxed and casual. And 'no shoes, no worries!'

Island life, my kind of life

135

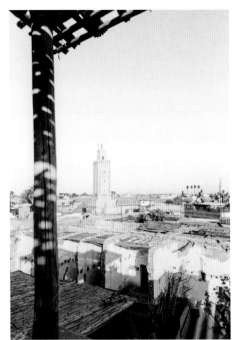

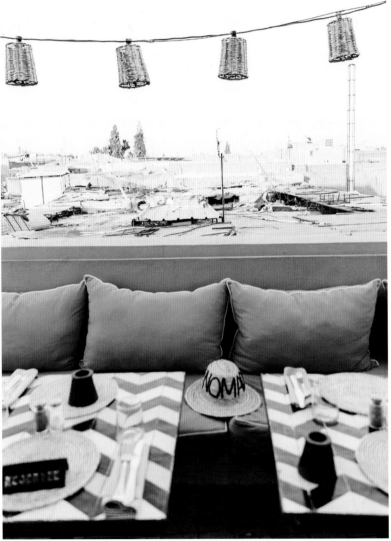

TOP LEFT Sunset on top of Atay Cafe,
Marrakesh Medina
BOTTOM LEFT La Famille Cafe & Shop
RIGHT Rooftop dining at Nomad Restaurant

# AFRICA:
# MARRAKESH // MOROCCO

As soon as you arrive in the north-west corner of the continent of Africa, greeted by the sight of powder-pink walls and served Moroccan mint tea from a gleaming silver teapot (on a matching tray), you know you've entered another world: the Red City.

Morocco is without doubt a magical place, one that had been on the top of my bucket list for its bohemian allure and exotic way of life – vastly different to the way I have lived. Its well-loved city of Marrakesh is intense, most definitely, but it's also a destination deeply embedded with iconic history, unique culture and traditions that transcend a typical postcard-perfect destination. This is a place that needs to be travelled with well-rounded research, a high level of awareness and respect, and an open mind – and preferably with a travel partner as well (something I personally recommend).

Getting lost walking through the souks in the Medina (Old City) is inevitable (and all part of the experience), photo opportunities present themselves endlessly (but be sure to ask first; it's a very sensitive matter), and seeing a new way of living leaves you inspired to try new things and learn something new.

Travelling to Marrakesh was the most wildly creative and artistic dream of mine that has come true, and I would make my way back in a heartbeat.

PREVIOUS Wandering through the
Old City
LEFT Beautiful details around
every corner of El Fenn

WANDER LOVE

# CHECK-IN

## EL FENN

A once crumbling palace that's been transformed into a beautiful boutique hotel, El Fenn is the ultimate place for creative and hip travellers to stay in Marrakesh. The evolution of El Fenn is a remarkable one: Vanessa Branson, the sister of Richard Branson, purchased it as a holiday home but has developed it into accommodation that now includes 28 individually styled rooms and suites, a rooftop terrace and restaurant (a dining must!), and a well-curated boutique filled with Moroccan brands. There are serene tree-filled courtyards where you'll occasionally come across a family of resident tortoises just casually hanging about. It's only a 5-minute walk from Jemaa el-Fnaa, the city's main square, and within walking distance of the bustling labyrinth of alleys in the Medina.

el-fenn.com

## LA MAMOUNIA

If you want to live like Moroccan royalty, then stay at La Mamounia. This palace-hotel is a truly exquisite 5-star (perhaps more) luxury wonderland. Its 200 guest rooms are set within 8 hectares (nearly 20 acres) of gated garden located right in the middle of the Old City next to the famous Jemaa el-Fnaa square. The hustle and bustle won't reach you inside its walls, though; as soon as you walk through the gate and enter the palatial premises you'll find yourself immersed in calmness and serenity – some kind of La Mamounia magic. You could easily spend a few hours exploring this Arabian fairytale of a world, with its exotic tile-work, opulent gardens, sparkling fountains and the most stunning outdoor and indoor pool areas. If a splurge on accommodation isn't in the budget be sure to at least treat yourself to a traditional Moroccan hammam treatment at the luxe spa, from where you can take in the sights of La Mamounia: both will be unforgettable.

mamounia.com

AFRICA: MARRAKESH, MOROCCO

## RIAD JARDIN SECRET

Just as Spain and Mexico have the casa (house), so Morocco has its riad. A riad is a large traditional house with a central courtyard, and in many cases in Marrakesh these houses have been converted into hotels. Riad Jardin Secret is the product of two love stories: the first between Parisian couple Cyrielle, a photographer, and Julien, an art director, and the second between the couple and Marrakesh. They fell in love with the city many moons ago, returning again and again. Wanting a profound change of lifestyle, they both left the fashion business and moved permanently to Marrakesh to create this authentic, private and creative haven in the antiques district. Its laid-back atmosphere offers guests a different pace of life, one that's simple and slow, the courtyard's home to two little dogs, beautiful palm trees, a swing and a natural outdoor shower. There are no televisions or air conditioning in the rooms but you'll find an abundance of nooks to lounge in and a teepee on the rooftop. Time spent here will inspire you to slow down, read, sketch, dream … Jardin Secret has a free-spirited Parisian charm and is also vegan friendly.

riadjardinsecret.com

## RIAD BE

Riad BE provides an otherworldly experience from the very beginning: after your airport pick-up, you'll be served mint tea and traditional sweets on arrival in their gorgeous boutique space that encourages you to just BE – happy, inspired, in the moment. It's in the heart of Marrakesh in Bab Doukkala, within easy walking distance of the souks and the most popular of the city's sites. Thoughtful touches give the riad a homey feel: books placed on a wooden ladder, travel guides and games, complimentary fresh fruit and a constantly replenished jug of cool water. From its interiors to its hospitality, Riad BE is extravagant yet artful, and it works.

be-marrakech.com

## RIAD YASMINE

Each of the seven rooms and suites at Riad Yasmine has its own private patio and distinctive decor that is a perfect balance between modern comfort and traditional styling. There's jungle wall art, a rooftop that's an ideal spot to unwind and the insta-famous pool that everyone who has made their way to Marrakesh has seemed to photograph really well (best done so from above, btw). It's less than a 10-minute walk to Ben Youssef Mosque, Almoravid Koubba and Marrakesh Museum, making it central and super easy for on-foot adventures.

riad-yasmine.com

Stay in a riad in the old medina of Marrakesh for a unique experience

# EAT & DRINK

### CAFÉ DES ÉPICES

With all the souk wandering you'll do in a day you'll need a great pit stop, and Café des Épices is an obligatory one. It's inexpensive, serves authentic Moroccan cuisine and provides an affable, relaxed atmosphere. You'll find woven stools and low wooden tables in the burgundy building where you can enjoy a long and restful lunch. Opt for one of their artfully designed sandwiches along with a refreshing juice while people watching over Rahba Kedima (the spice square – this cafe is at the opposite end to NOMAD) or catching up online using their free wi-fi.
cafedesepices.net

### NOMAD

For 'modern Moroccan' cuisine (traditional local cuisine and international dishes with a Moroccan twist), there's trendy NOMAD, tucked away in a corner of Rahba Kedima. It's a lively restaurant and you'll need to make a reservation if you want the best table in the house – and you *do* want the best table in the house – which is on the rooftop terrace in the corner closest to the square, beneath twinkling lanterns and with views above the Medina towards the Atlas mountain range. The interior is fresh and tasteful, a mix of Scandi cool and traditional Moroccan decor, and the food is focused on fresh, local ingredients. Moroccan khobz bread (a round flatbread) is served with every meal, and the popular seasonal mezze plate that comes with olives and yoghurt bread is a nice starter. Book in for a sunset dinner and soak up the Marrakesh magic.
nomadmarrakech.com

### EL FENN

If El Fenn isn't your home away from home while on your visit to Marrakesh, you at least need to visit for a meal. The best option? Drop in at noon for the day's set Moroccan lunch menu on the roof terrace; handwritten on a big black chalkboard, it changes according to what's in season. Or there's the Cocktail Bar & Restaurant downstairs as an alternative for a quality drink or intimate dinner.
el-fenn.com/eat-and-drink/

## ATAY CAFE FOOD

You'll be drawn in by the colourful rugs and mismatched furniture that create a chilled and comfy setting to enjoy a coffee (or mint tea) and watch the Moroccan world pass by. Well, I was, anyway. But don't just stop there; something new unfolds on each floor, the rooftop being the place to enjoy tranquil calm in the midst of the Medina. The rooftop is covered, the thin slats of the canopy creating intricate shadows in the afternoon sun; as night falls, the hanging lanterns provide a romantic, intimate ambience for dinner. Typical Moroccan fare is on the menu, and they also have Nutella crepes. You know how much I love Nutella crepes. Good news: Atay Cafe doesn't skimp on the Nutella.
facebook.com/ataymarrakech

## LE JARDIN

The first meal that I wanted to try when I arrived in Marrakesh for the first time was chicken tagine, a desire that was successfully satisfied at Le Jardin. If you feel like dining in a leafy botanical garden, make your way through its unassuming front door in the Medina for traditional Moroccan and European cuisine. You'll find the fresh produce on display at the entrance and it's a great option for either lunch or dinner, or just a cool drink among the lush greenery.
lejardinmarrakech.com

## LA FAMILLE

'Turn left, you'll find a black door in between two shops selling flowy kaftans – that should be it,' said the lady I asked on my search for this cafe, a place that I had pinned to visit. Sometimes all you want to do is take a break from the hot Saharan sun, and the calm within the chaos lies at La Famille: a lunchtime venue open noon–5pm situated in a rustic and charming Mediterranean-influenced garden. Stop by for lunch underneath the banana and olive trees and choose from their fresh and simple menu that changes daily. Or just enjoy a refreshing mint water, the glorious shade and a look through their cute shop stocking lovely leather goods, ceramics and jewellery.
instagram.com/la_famille_marrakech

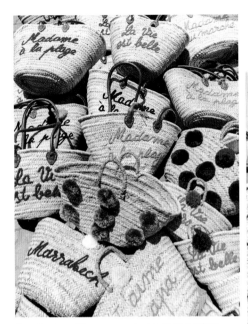

Overflowing with pompom and custom baskets

Mystical lanterns

Hanging rug colour combinations

# SHOP

## THE SOUKS OF THE MEDINA

The Marrakesh shopping experience would be incomplete without a wander through the souks of the Medina: the intricately connected alleyways of the Old City that are filled with stores selling lanterns, handmade silver jewellery, babouche slippers, poufs, leather-ware, pastries, Aladdin-like rugs and sooo much more. They're the heartbeat of the city. Shops in the Medina are generally open for haggling 10am–7pm every day except for Friday afternoon, when they close earlier. If you are on the hunt for something in particular or special, hire a guide. You'll not only greatly appreciate their knowledge, but they will be downright necessary to go deeper into the chaotic streets to find specific artisanal treasures. Otherwise, wandering through the souks and getting lost is definitely part of the Marrakesh experience – all five of your senses come alive. This is also a place where bartering is expected, so make sure you level up on those skills (*see* p. 186, How to barter like a boss).

## GALERIE DES CRÉATEURS

If you find the intoxicating pull of the souks a little overwhelming but still want to have a taste of it all, head to the shopping mall–esque galleried Souk Cherifia, just off Rue Mouassine. It's a traditional shopping centre that's open 10am–7pm and it has three levels: there are traditional Moroccan goods on level one; products with a modern twist made by local artisans and sold for a fixed price on two; and La Terrasse des Épices, a place to relax, grab a bite to eat and sip on a mint tea, on level three. The workmanship of the products here is also of higher quality than what you'll generally find in the Medina's souks.

## 33 RUE MAJORELLE

Contrary to the souks is 33 Rue Majorelle: a quality boutique concept store that represents more than 60 designers, most of whom are local maâlems (master craftsmen). The chic two-storey space – just across the street from the popular Jardin Majorelle (*see* p. 148) in the flourishing Guéliz district – is calm and filled with contemporary Moroccan fashion and homewares (plus a snack bar!). You'll find luxe boho–style apparel, studded babouche slippers, raffia ballet flats and espadrilles, colourful scarves, beaded earrings, patterned ceramics and silver teapots. Head here for an upmarket shopping experience.
33ruemajorelle.com

# DO

→ Wander through Jardin Majorelle (jardinmajorelle. com/ang/), a magical garden with magnificent trees and over 300 species of exotic plants, created by French painter Jacques Majorelle and later owned by fashion designer Yves Saint Laurent. It is now the eternal resting place of the haute couture designer.

→ Treat yourself to a traditional Moroccan hammam. This is a sensuous experience involving an exfoliating body scrub, a rhassoul (mineral clay) wrap and a calming massage with argan oil. Looking for recommendations? Check out Hammam de la Rose (hammamdelarose.com) and La Mamounia (*see* p. 141).

→ Explore Palais de la Bahia, built in the 19th century – its name means 'brilliance' and you'll experience a wealth of impressive courtyards.

→ Soak up the bustling, colourful chaos of Jemaa el-Fnaa square. There are snake-charmers, henna tattooists and acrobats, as well as live music.

→ Immerse yourself in the mosques: admire the intricate details of the zellige (mosaic) tile-work that covers the Ben Youssef Mosque in the Medina, and hear the call to prayer at Koutoubia Mosque, the largest mosque in Marrakesh.

Patio Noir et Blanc at La Mamounia

## TRAVEL TIPS

Summer (May–August) temperatures are intense and climb even higher beside the pink-walled buildings and within the narrow alleyways. Be sure to keep hydrated and schedule your exploring for the early morning or late afternoon to avoid the hottest times of the day.

The Medina is confusing and you will get lost. If someone comes up to you and offers 'help', be prepared to give them a few dirham if you accept.

Be aware of cultural sensitivities when taking photos – this is an activity that has traditionally been viewed with suspicion. Some locals may ask for a few dirhams in return, while others will not want their photo taken at all, and sometimes they may even yell at you just for taking photos nearby. *Always* ask before taking anyone's photo.

Keep your personal belongings close and guard your pockets as there are pickpockets aplenty.

Dinner at dusk overlooking Jemaa el-Fnaa

# PACK

Packing and dressing for conservative countries like Morocco can be tricky, especially when you're dealing with the hot hot heat. While it's respectful to stay covered, it's also essential to stay cool. You want to work specifically with breathable fabrics and pack loose and comfortable garments. Cover your shoulders, work with prints and colours, and always pack a hat.

Taking a mid-afternoon break from the heat at La Famille

# ASIA:
# PALAWAN // THE PHILIPPINES

**TOP LEFT** Filipino smiles
**TOP RIGHT** Pamper hut at Cadlao Resort, El Nido
**BOTTOM** Snorkelling at Siete Pecados, Coron

The Philippines, 'the pearl of the orient', is an archipelago made up of more than 7000 islands, with Palawan Island, the largest, ranked in recent years as the number one island in the world. Limestone rock formations, clear blue waters ... You're bound to have your own Moby 'Porcelain' kind of moment here (with a 1990s Leo surely completing the paradise starter pack). The most popular parts of this area of the archipelago include El Nido, a municipality on Palawan Island, and Coron, located on the eastern half of Busuanga Island.

Fun fact: El Nido on Palawan Island was actually the inspiration behind author Alex Garland's book *The Beach*. He wrote his bestselling novel while living in El Nido, but creative licence saw the movie set in Koh Phi Phi in Thailand, which has since exploded in tourism.

Both El Nido and Coron offer ultimate island bliss and, like any tropical destination, there are two seasons: dry (December–May) and wet (June–November). Once you've had a taste of either place I'm sure you'll have to return. All the more reason to explore both! Grab a buko (coconut) and let your hair down – it's time to live the island life.

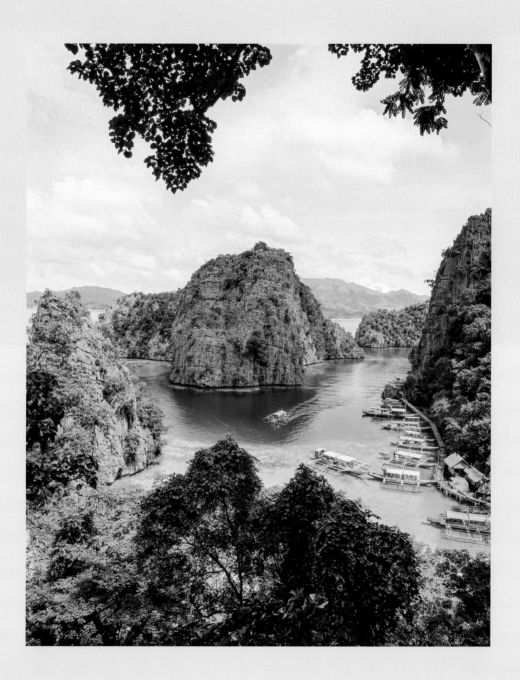

# CHECK-IN

## EL NIDO

### CADLAO RESORT

The French-Filipino couple who opened Cadlao Resort and Restaurant in 2011 have created a luxurious haven merging the best of both worlds: it's an island resort with service at your fingertips and the natural wonders of the coast off El Nido at your doorstep – there's an amazing view of Cadlao Island from the infinity pool. You can choose from sea- or garden-view rooms; all are styled simply. The garden is landscaped around the original coconut trees, and hammocks perfect for an afternoon siesta are scattered throughout. Breakfast is included in the cost of your stay and features baguettes (one of the owners is French, after all). Make sure to slot in an evening sesh at the relaxation hut for a full body combination massage. They use local organic oils, and the sound of the ocean during your treatment is absolute bliss.
cadlaoresort.com

### EL NIDO MAHOGANY BEACH RESORT

Mahogany Beach Resort is the place to stay for easy access to the restaurants and bars nearby in El Nido town proper. Book a cottage for two with its backdrop of coconut trees and the islands in Bacuit Bay, or a villa if you've rounded up a small group of friends to live the island life. The resort has an outdoor jacuzzi, and a modern design throughout that keeps the traditional local touch with details of fine wood and bamboo.
elnido-mahogany.com

### ECO-DISCOVERY ISLAND

Those looking to spoil themselves deserve a stay above the water at Miniloc Island's Eco-Discovery Island resort. Miniloc Island is in Bacuit Bay, off the coast of El Nido and Palawan Island. The resort has that Filipino coastal village vibe with rustic design that uses indigenous materials and features, including walls lined with woven bamboo slats known as sawali. Take your pick from water, sea-view, garden, cliff or beachside cottages. For the ultimate stay, the water rooms are built on stilts above the sea and set against the picturesque limestone cliffs.
elnidoresorts.com

ASIA: PALAWAN, THE PHILIPPINES

PREVIOUS The best hilltop views of Coron Island
TOP Infinity pool overlooking the West Philippine Sea
BOTTOM Sea or garden view rooms at Cadlao Resort

## CORON

### CORTO DEL MAR

You immediately feel the Spanish influence at Corto del Mar in its wooden sculptures, Neo-Mudéjar architecture and inviting outdoor pool surrounded by the hotel's 32 rooms and suites. You'll find mostly couples staying in this top pick – it's within walking distance of Coron town and the rooms are clean and spacious. Although there's plenty of room for improvement in the wi-fi department (it's practically non-existent in the rooms), this does allow more time to devour dishes from the restaurant's extensive menu (where there's a strong connection). Bonus points for Sunday specials – 50 per cent off pizza and pasta. Hello, pizza parties!

cortodelmar.com

## THE FUNNY LION

Don't be fooled by the quirky name – the king of the jungle isn't here to crack jokes. Instead you'll find a contemporary boutique resort just half an hour's drive from Busuanga airport. It's a little way out from the main centre of town but this is tranquillity at its finest, with rooms overlooking the ocean among virgin mangroves. Staff are always more than happy to arrange tricycles (a motorbike taxi with a pod for passengers to sit in) to get to and from the town, or if you feel like having a bit of a work-out complimentary bicycles are available. Special packages are also on offer, from the Wanderlust, which includes a tour around Coron for the adventurous, to the Serendipity, for romantics looking to take it easy with pamper sessions. There's even a Cherished Package, which includes babysitting for the kids so you can enjoy the best of island living. The Funny Lion has a little bit of something for everyone.

thefunnylion.com

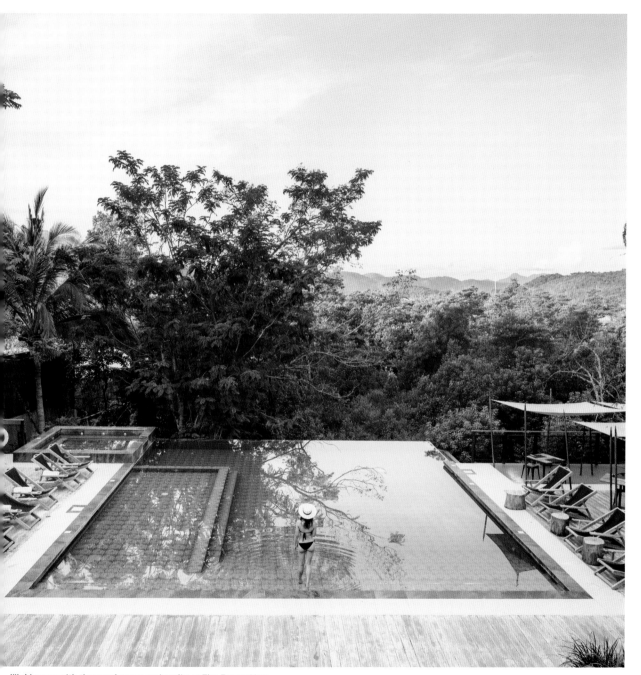

Waking up with the sun for a morning dip at The Funny Lion

Traditional Filipino breakfast of pork tocino (cured meat), fried egg and rice

# EAT & DRINK

## EL NIDO

### BY THE BEACH

Venture off to nearby beaches and you'll find different lunch packages by the sea. Sellers offer the day's catch cooked and delivered right to your spot on the beach. I'll always remember choosing the last few live crabs from a man's bucket and having them cooked and garnished for me straight away for a delicious seafood lunch, accompanied by coconuts freshly fallen from the trees close by, of course.

### HAPPINESS BEACH BAR

Spot the swings out front and you know you're in for a serotonin hit! Situated on the same street as the popular Art Cafe, Happiness Beach Bar is worth a stop for any meal of the day. Tuck into vegetarian food that's homemade and healthy, using only fresh local ingredients, and enjoy happy hour with two-for-one margaritas and daiquiris (note: they're strong!). You don't even have to be vegetarian to enjoy this place. Make sure to head upstairs to take in the view and sea breeze. A number one choice for delicious food, friendly staff and good vibes all round.

## ISLAND-HOPPING LUNCHES

When you go on an island-hopping tour be sure you choose to have lunch included. It's a feast! It typically features freshly caught grilled fish, prawns and squid, served with rice. The tropical fruit platters are cut and decorated nicely, and presented atop banana leaves. It's the ultimate experience of Filipino island life.

## CORON

### KAWAYANAN GRILL STATION

After a long day of activities, satisfy your stomach in the evening with the seafood platter at Kawayanan Grill, an alfresco-style restaurant with glowing lights and bamboo huts that give it a great ambience. It's a little further up the main street of town than the other restaurants and bars but still easy to get to by tricycle. Their smoothies and shakes are scrumptious, too.

### LOLO NONOY'S

Lolo Nonoy's, located in the heart of Coron town, serves up Filipino food that's full of flavour, and at around 200–250 pesos for a full meal you're sure getting bang for your buck. Leaving room for dessert is a must, and be prepared for buko as big as your head! Pop in a little earlier or later than the lunch rush to avoid waiting around for your food.

## PEDROS GELATO

A cute little place to get your ice-cream fix – and there's always time for ice-cream. Flavours on high rotation during my visits there included Oreo Cheesecake, Nutella, Chocnut (a classic chocolate flavour that's a Filipino favourite) and Ube ('purple yam' in Tagalog, the local dialect).

## SANTINO'S GRILL

While fresh seafood is expected on the island, the go-to restaurant for all things meat is Santino's Grill, situated a 5- to 10-minute tricycle ride from the main square. Cosy, with a typical nipa-hut setting complete with indigenous decor, Santino's is a place to simply enjoy good food. Baby back ribs are their specialty and highly recommended!

# DO

## EL NIDO

→ Take an island-hopping tour. There are four different kinds available to explore the coast off El Nido – they're called tours A, B, C and D, and start from 700 pesos. The most popular are tours A and C. Tour A includes Big Lagoon, Small Lagoon, Secret Lagoon, Shimizu Island and 7 Commando Beach – it's the perfect tour if it's your first visit to Palawan Island.

→ Hire a bike and venture to Nacpan Beach for the day. There are manual dirt bikes and full automatic scooters available for rent around town, but be sure to reserve one early as the motorbike shops are usually booked out by mid-morning. If you're not comfortable riding a bike, tricycles are plentiful – there's usually a line-up of drivers, just like a taxi stand.

## CORON

→ There's a range of island-hopping tours you can choose from to discover the area north-east of Busuanga Island. See the best of Coron on the Ultimate Tour, which includes snorkelling at the top seven highlights: Siete Pecados Reef, Twin Lagoons, Kayangan Lake, Beach 91, Skeleton Wreck, Malwawey Reef with its Coral Garden and CYC Beach. You'll be pretty much set to enjoy the day free from worries, with access passes, hotel transfers, light snacks and an island-style buffet lunch all included.

→ Visit Calauit Safari. Free to roam this reserve and wildlife sanctuary are eight different species of African animals, including giraffes, zebras and gazelles. The animals were transported from Kenya to Calauit by ship, and it's fascinating to think that this secluded location in the Philippines was judged ideal because of its size, terrain and vegetation to help save African wildlife threatened by war and drought in the 1970s. Tip: for a fun ride between the stops ask to sit on top of the jeep for better views. Just remember to hold on tight!

→ Take a dip at Maquinit Hot Springs. It's claimed that this is the only hot spring in the Philippines with salt water – and personally, I think it's one thing you shouldn't miss. Do: hop on a tricycle and head there at night after an island-hopping tour. It will be, without a doubt, one of the best ideas you'll have had on the island. Cut-off time for admission is 8pm, giving you a good 2 hours to relax and unwind until the 10pm close. Don't: visit on a hot afternoon. The water temperature is around 40°C, and boiling in the water under the scorching sun won't be pleasant!

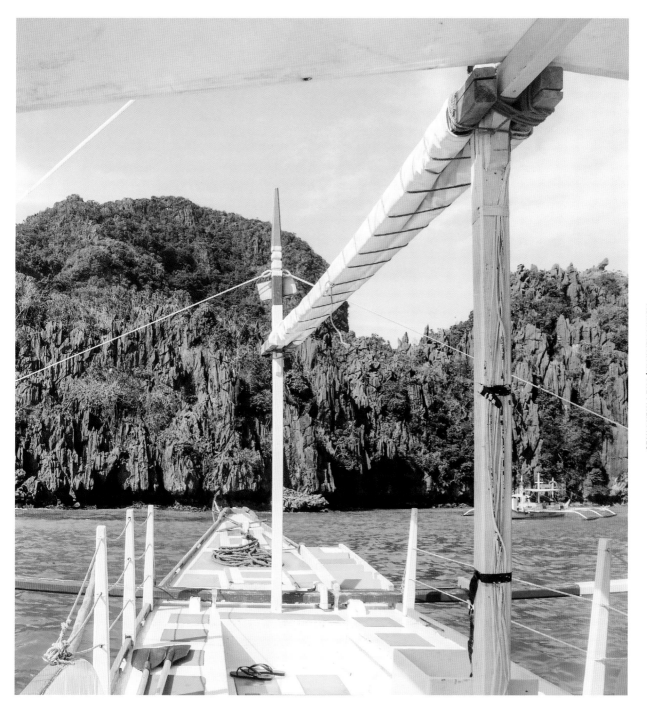

Island hopping amongst turquoise waters and limestone cliffs

## TRAVEL TIPS

There are a few ATMs in El Nido and Coron but beware of cash-out limits and power outages that render them useless. Best to budget for your time there and bring cash.

Daily power outages are the norm so don't be surprised if you're eating dinner in a darkened restaurant or the lights suddenly go out while you're taking a shower. Stay calm. Larger establishments generally have backup generators, though.

Protect your camera or phone with an underwater case if you're going on an island-hopping tour – it's highly likely it will get wet. You're going to want to practise your 'I'm diving with snorkel gear on and still look graceful' poses prior, because the water here is that sparkling aqua hue perfect for all those underwater shots the babes are doing.

When taking a tricycle, tell the driver where you need to go and arrange a price before hopping in.

A colourful mode of transport – the Filipino tricycle

# PACK

It's raw and real on the islands with few stores that sell clothing. A minimal island look is best – natural hair and makeup, colourful, comfortable clothing and most importantly a happy smile to match the islands' good vibes.

Keep it au naturel on the island

# 4.

## MARKET LOVE ♥

## TREASURE HUNTING ON YOUR TRAVELS

**ATTN: Avid treasure hunters.**

It's safe to say that the memories we create and capture on our travels are the best souvenirs to take home. But let's be real: there's no harm in a little retail therapy.

From farmers' to vintage fashion, markets make for an all-encompassing experience in a new and unfamiliar destination. The food, the wares sold by the local stallholders, the artisanal treasures ... One thing's for sure when you enter the market life: you never really know what you'll end up leaving with.

I find it intoxicating; it's like modern-day treasure hunting. Armed with a pocketful of cash and some bartering skills (*see* p. 186) but no expectations – *always enter with no expectations* – scouring the markets for curiosities is one of my favourite things to do.

Artisanal goods are always worth seeking out over mass-produced souvenirs – usually handmade, they are so much more special. And when it's been a successful day at the market, know that finding a post office to ship home your copious amounts of woven treasures from that dusty market in South America is an alternative to an overflowing suitcase. But FYI, it's expensive.

Worth it?

Most definitely.

Every piece has a story to tell.

Following is a hand-picked collection of markets from around the world where I've found some proud treasures.

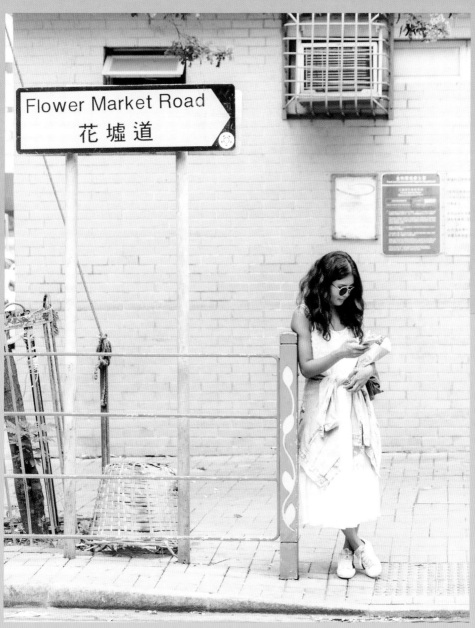

**PREVIOUS** Vintage camera collection at Portobello Market, London
**ABOVE** New message: just got to Flower Market Road, Hong Kong. Coffee after?

# MUST-VISIT MARKETS AROUND THE WORLD

## THE UK

### Brick Lane Market, London, England

Although the restaurants and shops are open every day of the week on Brick Lane, the best day to visit is on Sunday (10am–5pm) as the street comes alive with stalls and street performers for Brick Lane Market. There's a bargain to be found if you search hard enough, otherwise a stroll with your camera and a keen eye is also well worth it. This market is a top pick in my book for people watching over a coffee – there's such a diverse range of individual styles. Be sure to pop into Kahaila cafe for a slice (or two … no judgement, I swear) of their scrumptious red velvet cake.

What you'll find: clothing, bric-a-brac, second-hand furniture and plenty of stylish young Londoners fit for a street-style snap.
visitbricklane.org

### Columbia Road Flower Market, London, England

Whether or not you plan to pick up any blooms, time spent strolling through this bright street market will give you heart emojis in replacement of your eyes. To visit this oasis in East London overflowing with flowers and foliage, set aside an hour between 8am and 3pm on any Sunday.

What you'll find: an abundance of colour, a Sunday serotonin boost, oh and of course the freshest, most beautiful blooms!
columbiaroad.info

### Portobello Market, London, England

Welcome to pastel paradise! As one of London's best-loved landmarks, Notting Hill's Portobello Road, lined with pastel-painted terrace houses, deserves to be thoroughly explored with undivided attention – it's best visited on a Saturday when things are in full swing. The street has been home to the market since the 1800s, becoming particularly famous in the 1950s for its antiques. Thoughtful gifts can definitely be found here: my favourite vintage book on butterflies, beautifully tattered with pages that smell of an old bookstore, is proof of a heartwarming surprise. I may or may not have strolled through this market wearing a beret, Lolita-style cat-eye sunglasses and a leather jacket. Plenty of tourists: yes. Plenty of history: no doubt. Getting into character à la Julia Roberts as Anna Scott: optional, of course, but highly encouraged.

What you'll find: antiques, vintage and second-hand fashion, fresh fruit and vegetables, bric-a-brac and cute London boys busking to The Beatles.
portobelloroad.co.uk

Fresh blooms from as low as £5 at Columbia Road Flower Market, London

## EUROPE

### Grand Bazaar, Istanbul, Turkey

No other market is quite as enchanting as the beehive that is Istanbul's Grand Bazaar: full of trinkets and treasures, it's one of the most celebrated attractions in the world. Lining the walls are rainbows of kilim rugs and embroidered bags, along with brightly coloured ceramics and glowing lanterns that will have you wishing for more luggage space. It's open weekdays and Saturday from 8.30am to 7pm, and closed on Sunday and religious holidays. Located adjacent to the Grand Bazaar is another of the most colourful destinations in the city – the spice markets, which are also a sight you must see while you're there.

What you'll find: handicrafts, home decor, textiles, jewellery, tableware and a rich Turkish culture.

### La Boqueria, Barcelona, Spain

Unmissable from the popular La Rambla Boulevard, La Boqueria sits at the top of Barcelona's 'must visit' list. It's open 8am– 8.30pm every day except Sunday, and if you're spending a decent length of time in this city multiple visits for breakfast are non-negotiable. You'll never run out of new frutas (fruits) and jugos (juices) to try – the perfect way to wake your tastebuds and make them tingle at the start of the day. Trust me.

What you'll find: aisles overflowing with fresh frutas, €1 jugos, gelati and popsicles, chocolate, vegetables, exotic spices, seafood and copious amounts of colourful candy.
boqueria.info

### Marché aux Puces de Saint Ouen, Paris, France

A visit to this market, one of Europe's biggest flea markets, is almost like visiting a museum, it has so many objects of art scattered throughout. The market has two entrances, both off rue des Rosiers at either end of the street. Take line no. 4 of the Métro and get off at Porte de Clignancourt to enter at the sections dedicated to new items, or take line no. 13 and alight at Garibaldi station (get off there instead of Porte de Saint-Ouen for a shorter walk) to go in from the quieter end of the street. Whatever you decide, just make sure you also wander off rue des Rosiers for some treasure hunting in the shops and warehouses in the surrounding streets and alleys. The perfect place to practise your French on the weekend? Oui!

What you'll find: antiques, home decor, vintage cameras, furniture, unrestored objects … the list goes on.
marcheauxpuces-saintouen.com

Colourful jugos at La Boqueria in
Barcelona, Spain

Contemplating if increasing my luggage weight
for travel treasures is a good idea

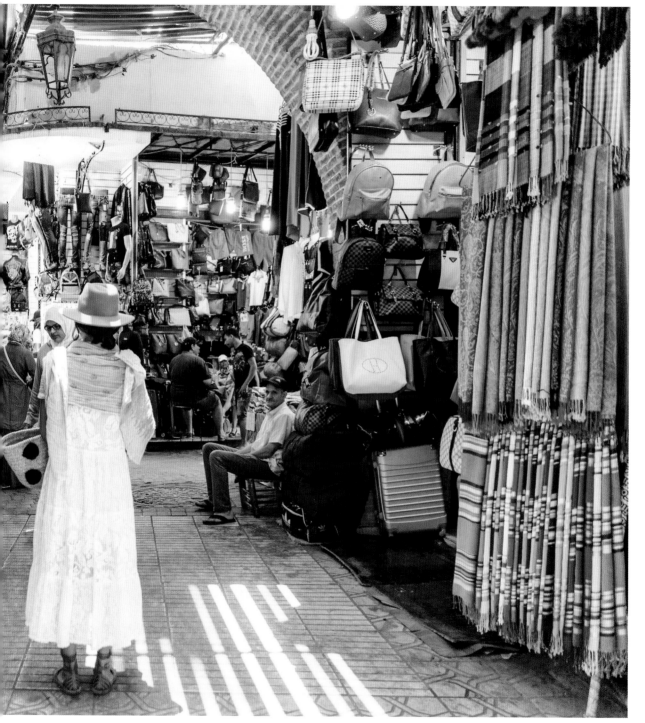

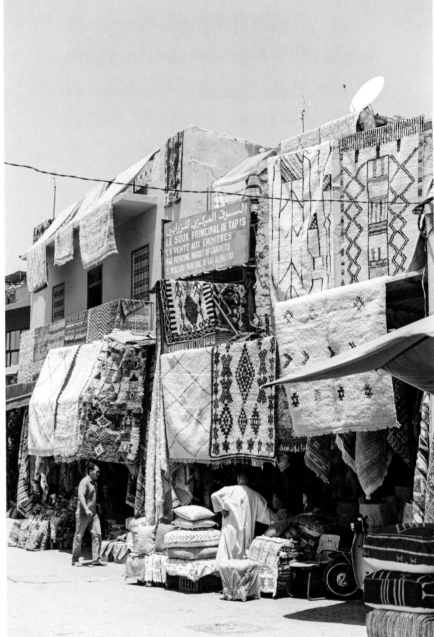

Custom embroidery on straw hats

## AFRICA

### The souks of the Medina, Marrakesh, Morocco

There's a kind of magnetic pull to the markets of Marrakesh. They're a labyrinth of narrow alleys filled with shops selling traditional artisanal goods and souvenirs. You'll find plenty of treasures in the Medina, which is open every day and also conveniently surrounded by restaurants. There are a couple of cute cafes that are good for lunch, too, overlooking the crowds. (*See* pp. 144–5 for further information.)

What you'll find: rugs, leather sandals, pompom- and custom-embroidered straw baskets and sun hats, babouche slippers, spices, rugs, blankets, metal furnishings – oh, and did I mention rugs?

## ASIA

### Chatuchak Weekend Market, Bangkok, Thailand

Conquering the Chatuchak (or Jatujak) Weekend Market in Bangkok may seem like a daunting task when you arrive. There are 27 sections spread over more than 110,000 square metres (130,000 square yards), which can feel as overwhelming as the souks of Marrakesh. The trick is to choose a strong starting point for your market wander. I suggest beginning with section 6: sawasdee, vintage heaven! Think mountains of 1970s Levis and never-ending racks of Hawaiian shirts, distressed denim jackets, reworked dresses and so many more treasures for both women and men. Top off your visit with a meal from the food stalls just outside section 6 and enjoy it in nearby Chatuchak Park. It's best to arrive around 10am, when the stalls open – ideal for scoring a bargain and beating the swarming crowds.

What you'll find: sections 5 and 6 are notable for second-hand and vintage clothing, section 1 for books and section 8 for home decor and decorative objects. chatuchak.org

### Flower Market Road, Mong Kok, Hong Kong

Another serotonin boost more than 9000 kilometres (5600 miles) from my London favourite is Flower Market Road, an open-air street market serving up a chaotic jungle of colourful exotic blooms from 9.30am to 7.30pm seven days a week. Pencil in a mid-morning visit (take Exit B1 at Prince Edward Station): stop for a coffee break among the botanical bliss at Cafe Hay Fever, then finish the scent-filled walking tour with lunch at One Dim Sum close by.

What you'll find: fresh cut flowers, bonsai trees and exotic plants. flower-market.hk/

### Ubud Art Market, Bali, Indonesia

Pasar Seni Ubud, as the locals call it, is a traditional market located at Jalan Raya Ubud No. 35, opposite the Royal Ubud Palace. It's open every day 8am–6pm. Early mornings are the best time to scour the market and pick up a bargain because there are fewer crowds and vendors are more likely to give you their best price – they believe that the first sale of the day is good luck. So get in early and ask for harga pagi (price morning), i.e. the morning price. Most stalls have no set prices on items so a friendly barter is expected. Personally, I find the beautiful silk scarves and baskets of all kinds too good to pass up.

What you'll find: Balinese handicrafts, baskets, ikat and batik patterned textiles, jewellery, home decor and souvenirs.

Perfectly packaged blooms on Flower Market Road, Hong Kong

A beautiful selection of vintage books at Camberwell Market, Melbourne

## OCEANIA

### Camberwell Sunday Market, Melbourne, Australia

Since 1976, this suburban carpark in Melbourne's east has been a mecca for lovers of trash and treasure every Sunday from 6.30am to 12pm. It's sometimes a hit and other times a miss, but at least you know you've left a gold coin donation to fund charitable causes.

What you'll find: second-hand and vintage clothing, bric-a-brac, antiques, hot jam doughnuts and buskers that will make you want to have a little boogie while enjoying those doughy treats.
camberwellsundaymarket.org

### Queen Victoria Market, Melbourne, Australia

Queen Victoria Market is a historic landmark in Australia's top foodie city and the largest open-air market in the Southern Hemisphere. It's not just a place to spoil your tastebuds, but arrive hungry because if you go there for anything, go there for the food. Refer to it as Vic Market or Queen Vic for that added 'I'm-a-local' effect.

What you'll find: local and imported gourmet food, souvenirs and an amazing market atmosphere five days a week.
qvm.com.au

### Rozelle Collectors Market, Sydney, Australia

The grounds of Rozelle Public School in Sydney's inner west have hosted a weekend market from 9am to 3pm for more than 20 years now. It's the Sydney market where you're most likely to score designer items from the fashionable crowd at bargain prices.

What you'll find: second-hand and vintage fashion, antiques, records and homewares.
rozellecollectorsmarket.com.au

### Surry Hills Markets, Sydney, Australia

I occasionally sell my vintage and second-hand wares here when I'm in town but you're most likely to find me neglecting my stallholder duties, soy latte in hand, shopping at the other stalls instead. Oops. There's a little something for everyone here. Located on the famous Crown Street in this inner eastern suburb of Sydney, the market is held on the first Saturday of every month from 7.30am to 4pm.

What you'll find: second-hand and vintage clothing, handmade goods and bric-a-brac.
shnc.org/events/surry-hills-markets

## NORTH AMERICA

### Brooklyn Flea, New York, USA

Hands down a top market to hit while you're in the concrete jungle. It's held on the weekends in Soho at 100 Avenue of the Americas, but I particularly love Brooklyn Flea in DUMBO (short for Down Under the Manhattan Bridge Overpass), a seasonal alfresco market held on Sundays from 10am to 6pm (April–October) under the Manhattan Bridge Archway. You can feast your eyes not only on spectacular city views but also on treasures from 80 vendors across diverse styles, cultures and items. Just be sure you don't make the mistake of not buying an item you particularly fancy right away – it may not be there when you come back. Barter and purchase quickly or you'll miss out in the fast pace of it all!

What you'll find: vintage clothing, jewellery and accessories, home decor and bric-a-brac.
brooklynflea.com

### Rose Bowl Flea Market, Los Angeles, USA

On the second Sunday of every month more than 2500 vendors and around 20,000 visitors flock to sunny Pasadena for Rose Bowl Flea Market: a pride and joy of Los Angeles County for more than 45 years and a globally recognised outdoor market experience. General admission starts at 9am at US$9 per person, but VIP, early bird and express admissions are also available (see website for details). To seamlessly tackle each section of the market, which is open from 9am to 4pm, make sure you grab a map at the information centre located immediately to your left as you enter the market. Then plan your wander section by section to divide, see and conquer.

What you'll find: clothing, furniture, vintage goods, collectables and art.
rosebowlstadium.com/events/flea-market

Matchy-matchy market wares in New York: huaraches I purchased for $10 and basket for $5

Left or right? Woven backpack decision-making.

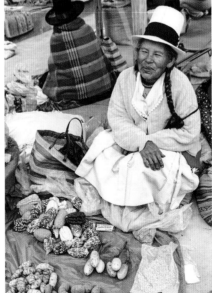

Handmade pouches in different colours

Early morning smiles

## SOUTH AMERICA

### Chinchero Market, Chinchero, Peru

Between Cusco and Urubamba in Peru lies a small village in Sacred Valley called Chinchero, where you'll find an open-air market held on Tuesdays, Thursdays and Sundays. It starts around 9am and wraps up just after lunch on each day. The market is largest on Sundays, the day that most locals visit and the best for a Peruvian market experience.

What you'll find: handicrafts, lots of colourful woven bags, cushions and rugs, and Peruvian food to enjoy throughout your stroll.

# HOW TO BARTER LIKE A BOSS

→ First, know your sh*t. Research online what to buy and note down approximately how much you should be paying for each item in local currency. Bring cash, always; watch for pickpockets, too.

→ Show up sans expensive gear (no DSLR camera, bling bling or obvious designer wares).

→ Don't peak too early. Do a loop of the market, ask for the price/s of the item/s you're interested in and compare to surrounding stalls.

→ Look out for stalls where you can bundle purchases – it's easier to ask for a good deal when you're buying multiple items from the same stallholder.

→ Make an offer of half of the initial asking price. Increase by 20 per cent at most.

→ Be friendly, but firm. But friendly.

→ If negotiations aren't running smoothly, say thanks in the local language and walk away. Most of the time you will be called back, but be prepared that this may not happen …

→ Be called back.

→ Happily return. Agree on your final price. Exchange cash for treasures.

CONGRATULATIONS! You've successfully bartered like a boss.

*CUE* Dance in front of the mirror at home with your new goods.

Buying custom baskets in bulk and deep
in bartering action in Marrakesh

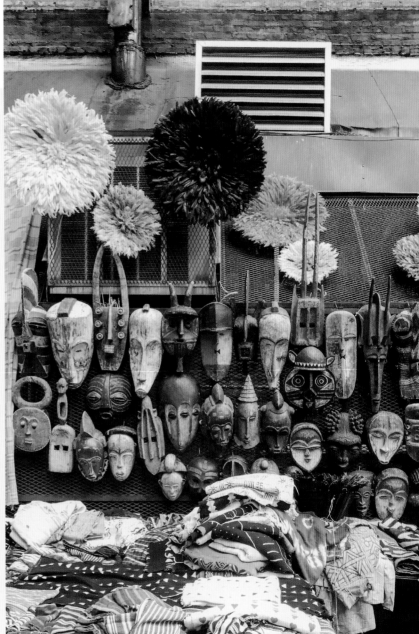

Wooden African masks, juju hats and textiles in New York

Pretty vintage shoes one size too small for me

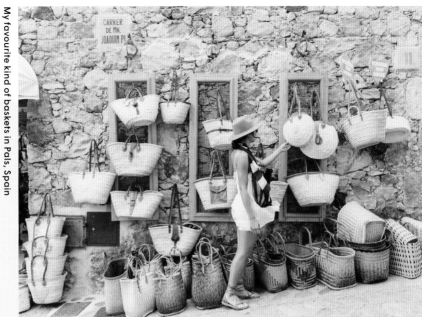

My favourite kind of baskets in Pals, Spain

Traditional Colombian hats galore in Bogota

# 5.

# THE TRUTH ABOUT TRAVEL ▼

## LIFE LESSONS FROM SOLO TRAVEL

You. I know *you*. You're the kind of person who loves to dream up new adventures, both near and far. You're a curious soul, have a creative heart, are always seeking to discover unexplored places and meet new faces. Your mind escapes to other corners of the world through beautiful travel photographs, and you live vicariously through your favourite travel blogs, which are a constant source of inspiration in everyday life.

I also know that you've been wanting change for a while. What kind of change, exactly? That's probably something that you haven't quite figured out yet.

It's not hard to understand why you're completely and utterly enamoured by the idea of travel. Let's face it, we can always do with a little more adventure in our lives.

Travelling solo for the first time – especially for a young woman – is completely terrifying. Stepping out of your warm and fuzzy comfort zone is a difficult thing to do. Don't worry, I feel for you. But you know those things that scare you and excite you at the same time? They're the things absolutely worth doing in life. There's so much to learn.

No doubt the pessimist in you will be saying: the most horrible things can happen unexpectedly.

But as an optimist, let me tell you: the most beautiful things can happen, too.

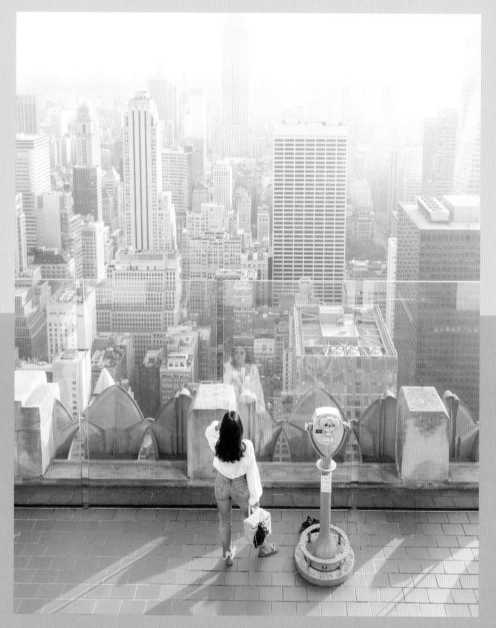

PREVIOUS Skin is tanned, hair is (extra) curly, heart is happy living the island life in Indonesia
ABOVE Someone pinch me, I'm on top of the world (!!!)

# TIME IS OUR MOST VALUABLE CURRENCY.

It's the end of November 2016, and I'm checking in at the Freehand Hostel, an artsy place in Miami Beach, Florida. I'll be living on the road again for the next three months. I've just finished a photography job on a cruise ship and have chosen to spend some time exploring the city, with Mexico next on the agenda.

I spot a postcard stuck on the wall next to the counter, slightly torn at the edges and with a few words written on it. 'Take Time' are the two that catch my eye, and the words that follow are a gentle reminder that we need to spend our time doing things that will enrich our lives.

When you're travelling on your own, you spend a lot of time with yourself, and you can spend your time however you want. You have time to reflect on what really matters to you. Who you choose to spend your time with and what you choose to spend your time doing play a big part in who you will become as a person.

Time can seem to move faster or slower depending on what you are doing, and enthralled by an awe-inspiring experience, it can feel like time doesn't exist. But it never stops moving forward.

What they say is true: time is the most valuable currency. Choose to spend it wisely, doing the things that make you happy. Choose to be on time, always, to show respect for other people's time. Choose to truly embrace the present moment – it is all the time you actually have.

Taking time out at Miami Beach, USA

# RELATIONSHIPS COME AND GO ON THE ROAD.

When you travel solo you meet a lot of people. Most will be passing acquaintances, and a handful will become deep and genuine friends. The chance of finding romance on the road is real, but the nature of travel doesn't always lend itself to successful long-term romantic relationships. Everyone is moving in different directions – holidays end, plans change – and it's hard to make something last when you've got your own agenda (which you should have to begin with, by the way, because #youbestbedoingyou).

Getting attached too often will only bring heartache and leave you feeling empty. Enjoy your time together but have no expectations and, most importantly, know your values and act accordingly. Be completely and wholly present in each moment – it's the best way to have the most fun and live most freely on the road. There is really no point worrying about the future or comparing the present with the past. I believe people come into your life for a reason; be open to them, because you never know what you will learn. Some people might even stay for keeps.

Fall in love with the motion of life – everything is how it's meant to be.

To put it simply in Español: Que será, será. (Whatever will be, will be.)

Camping adventures in
Blue Mountains, Australia

# EXPECTATIONS ARE THE ROOT OF ALL DISAPPOINTMENT.

Have you ever dreamed up what a monument looks like – imagined its size, its surroundings and how you will feel when you get there – and then, after flying across the world to see it, felt disappointed? It's common to arrive in a destination with preconceived ideas of what will greet us there, but it's important to recognise that the real thing may be a little different – and this applies to every aspect of the trip. It's true that nothing beats the anticipation of travel: the excitement, the daydreams, the images that you will finally be seeing IRL, even the pre-departure-just-paid-for-my-flights-help-me-I'm-poor state. It all, in its own way, brings happiness prior to the journey itself. But the reality is that your imagined destination will never match up exactly with what's really there, and it's also a fact that as much as you prepare for something, things can and will change. When you travel, some things won't go to plan – flights will get cancelled, luggage will get lost, connections with people will fall through. When the unexpected happens, it may not be for the worst, it may just be different.

Arrive with plans but no expectations, and you'll be pleasantly surprised.

# THINGS ARE JUST THAT – THINGS.

I was travelling in Mexico and, after a bike ride and fun night out with old friends and new that I met along the way, my iPhone somehow got lost. I had travel insurance (you should always have travel insurance), and while the phone was expensive, what really sucked was losing the images and memories captured on the camera roll.

Be prepared to lose things on the road: your favourite sunglasses, a wallet full of cash and cards (*fingers crossed it doesn't happen to you tho*), an iPhone with photos that were never backed up. Sometimes it will be taken from you (damn those pickpockets!), and sometimes it will be your fault. Try not to dwell on the negative too much or let it bring you down. Complaining never got anyone anywhere. Your two feet stepping one in front of the other will take you to more places – and have you moving forward – more quickly.

Things alone don't make you happy. What you own is not who you are. Things are just that – things. My first solo travels around South America, accomplished with just two backpacks, made me realise how little we actually need. Travel is the art of minimal living, showing us that it's our experiences that make us truly happy.

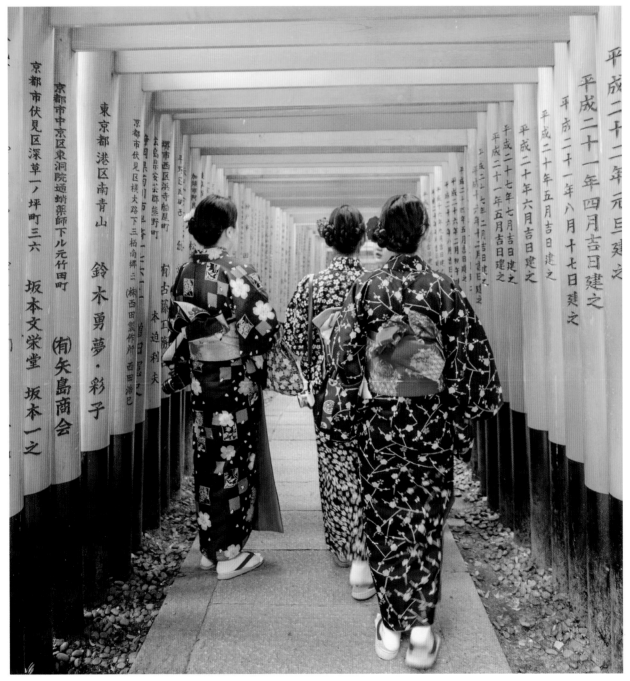

Fushimi Inari Taisha: a Shinto shrine in Kyoto,
Japan famous for its vermillion torii gates

# THE REAL WORLD IS A SOLID EDUCATION.

When we are thrown in the deep end in life there are two options: sink or swim. Time on the road on your own will be a constant stream of highs and lows, and will bring a crazy amount of realisations and knowledge. You will learn so many things out in the real world. Things that can't be taught in a classroom but only learnt through firsthand experience.

This could be anything from learning an artistic skill that has been passed down through generations, like the time I learnt how to weave on a traditional backstrap loom from a ten-year-old Peruvian girl, to simply using the local language as much as possible to make for a more well-rounded travel experience. Even if you use only a few key phrases that you've picked up through hearing them repeated on the streets, it shows that you're open to the culture and you're willing to make an effort. It'll also help you in your interactions with others in situations both pleasant and unpleasant (and how you deal with the latter can be a lesson in itself).

When you travel, don't ignore the culture, be completely unresponsive to the language, or choose to do only the things that you can do at home. Instead, let your experiences overflow with everything unique that the country has to offer. When we learn more about our world, we also learn more about ourselves.

Just be open to learning. Every. Single. Damn. Day.

# INSPIRATION IS EVERYWHERE.

There is beauty in every little detail: in vibrant colonial architecture, the energy and rhythm of life in a particular city, the style of costume in a traditional dance, the distinct scent of incense used in a ceremony. The beauty of travel is that we all see things differently, but will each surely be inspired in some way, shape or form. Capture your thoughts and experiences, write all the details down – these will serve as beautiful reminders or the beginning of new and grand ideas.

Intricate details of Ben Youssef Madrasa, Marrakesh, Morocco

# YOU CREATE YOUR OWN REALITY.

Buenos días! It's Wednesday 24 May 2017, 6.24am. I've just woken up and I'm in Girona, Spain, my first time here. As a rule I start my mornings with a session of stretching. It's so underrated, but I find it one of the best feelings – it's one of the reasons why I love yoga, along with the practice's other physical and mental benefits (my preferred style is Ashtanga). Because I travel so much it's not realistic for me to attend classes at a studio, and so I take my practice with me. I usually practise on the floor by my bed, or wherever space in my hotel room allows. However, as I'm staying at the beautiful Mas Lazuli Hotel, I'd be silly not to go outside and enjoy my morning stretch by the water. It will be the perfect start to my day.

Whatever you're considering doing in your life – changing career, moving to a new city, even making a small change in your day-to-day life, like establishing a good daily habit – it's never too late to make it happen. Your life is yours alone. People can persuade and influence you, but ultimately it's you who will make the decisions. Create moments you're glad to say you've experienced, face challenges you'll be proud to say you've overcome – a life you're happy to say you've lived when you're finally old and wrinkly. Today is wild. And it is *yours*. Make sure the path you decide to walk on aligns with what you stand for.

# YOU CREATE YOURSELF.

Prior to setting out on my own solo adventures I had heard the stories about what travelling solo did for women – how it changed them, how they grew, and that well-worn cliché, how they 'found themselves' out there in the world. Honestly, though, I completely disagree. Instead, I think when you set out on your own you *create yourself*. You show yourself who you really are, or who you have the potential to be, in the different scenarios you find yourself in. Your true character will show in how you treat those who can do nothing for you. On the road you can be anyone you want to be … but it's a beautiful thing when you choose to be yourself – to create yourself – and become the person you want to be. The better version of yourself.

Poolside breakfast in my Moroccan riad

# WHEN YOU BECOME COMFORTABLE WITH BEING UNCOMFORTABLE, YOU ALLOW YOURSELF TO GROW.

I still remember how I felt during the first couple of days of staying in a hostel for the first time: it felt really strange. I was only familiar with hotel life, travelling with a partner, friends, family – someone I knew – and here I was creeping down the hallway on my tippy toes at half past midnight, on the other side of the world, quietly checking into a shared dorm in the company of two guys I didn't know. Hesitations about my decision came to the surface but I navigated through them smoothly by finding a balance between being approachable and gently making it clear I had boundaries – these guys were essentially strangers, after all. My roommates turned out to be a lot nicer than I had expected. One was from Texas; the other, from Amsterdam, eventually became one of my closest friends on this trip. I also remember being fearful of going out in a new country after dusk – I was afraid of getting lost and not knowing how to get back to the hostel, because I didn't know how to speak the local language to ask for directions.

All of these fears eventually faded. Most of the time they're just tricks of the mind. No matter how awkward you may feel, cast yourself out of your comfort zone and into the world of uncertainty. This is where sparks fly, where the magic happens – not magic in the mystical sense, but the ordinary, everyday kind of magic that can happen to any of us if we're open to it. This is the space where we grow. There is magic in a person who feels confident, standing steadily and happily on their own: doors open to new opportunities, relationships improve, energy soars.

At first you will feel that constant pull between comfort versus courage, but with a little practice of feeling the fear and doing it anyway, you may even find yourself in the weird situation of being comfortable with being uncomfortable – I know I have, anyway.

This is not to say that there won't be times when feeling uncomfortable means you should avoid certain situations. Knowing the difference between uncomfortable that is okay and uncomfortable that is not is where intuition comes in …

# INTUITION IS SOME KIND OF SUPERPOWER.

Don't underestimate it.

Feel it.

Trust it.

Follow it.

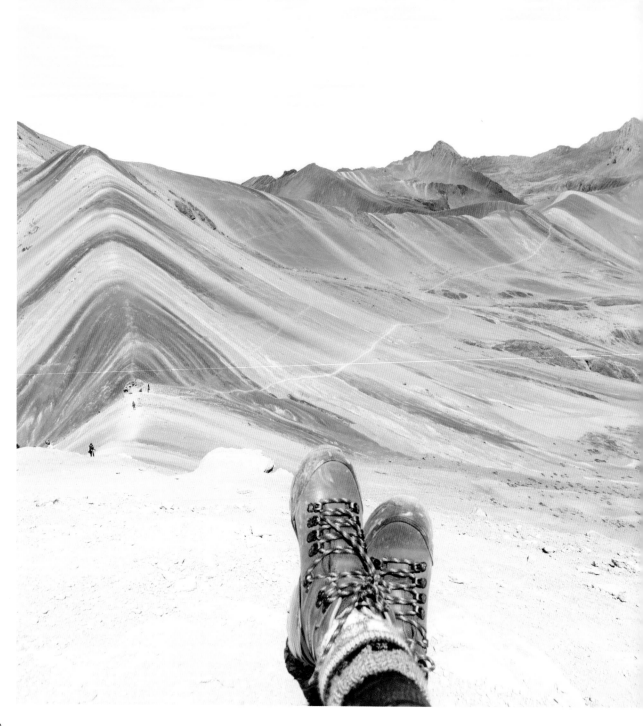

# YOU ARE ALL
# THAT YOU NEED.

It's 9.22pm on a Monday night and I'm in Cusco after travelling here from a photography job in Rio de Janeiro, Brazil. It's the beginning of my South American journey and I've arrived solo and tired, my accommodation unconfirmed. Standing next to me at luggage collection is a beautiful Latino couple, loved up and waiting for what I assume will be backpacks to match their hiking attire. Their luggage arrives: his first, followed by hers. He picks up and carries both, one on his back and the other in front. Carrying my bags is the last thing I want to do after 24 hours plus of flying, full days of on-location shooting and the anxious feeling of not knowing where I'll be sleeping that night. But when you travel solo, you have no one else to depend on except for yourself, from little things like carrying heavy bags and booking transport and accommodation, to more challenging aspects such as navigating your way through a new place and adapting when situations don't go in your favour.

Relying on yourself and your own resources has so many benefits. It allows you to identify what you really want to do, and you get to make all the decisions (no making sacrifices for anyone else!). You figure everything out on your own, like little flying hacks such as how nabbing a red-eye flight from one destination to another will help you save money on accommodation, even if it's just for one night.

To sum it up: solo travel is liberating and empowering. You find that you are all that you need; you find yourself whole. So whole that everything else – everyone else – is just a bonus.

**Taking in the views from the top of Rainbow Mountain in Peru**

# THE MOST IMPORTANT RELATIONSHIP IS THE ONE YOU HAVE WITH YOURSELF.

And after all the people you've met, all the people you've loved and lost along the way, all the lessons you've learnt, comes the most important thing of all: self-love. And with it the ever so addictive sweetness of solitude. Eventually you understand that in order to love anyone else properly you first need to learn to love yourself.

**Endless seas in the Philippines**

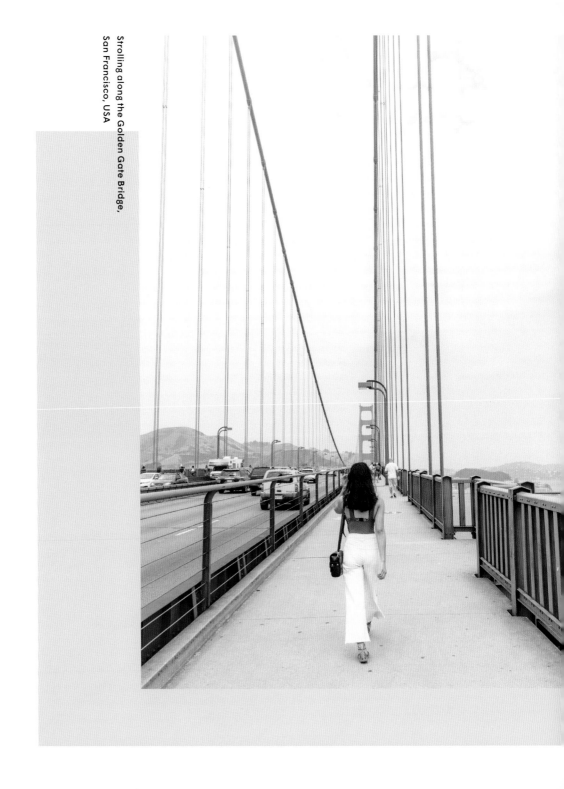

Strolling along the Golden Gate Bridge,
San Francisco, USA

All the essentials for a relaxing afternoon

La Mamounia dreaming in Marrakesh, Morocco

# 6.

# THE PHILOSOPHY OF TRAVEL

Beyond the pretty posed pictures and all things external, there's a deeper benefit to travel that is often overlooked. One that looks inward towards personal growth. One that is a way to truly get to know yourself instead of spending all that time getting to know others. One that is an endless journey of self discovery.

You can travel creatively, attending to your interests and passions, the things that light a fire in your soul. You can unleash your curiosity, giving yourself space and time to learn about the world and let your own story unfold. You can pay attention to the world around you, being self-aware and in the moment, travelling mindfully so you can truly enjoy your time and grow to be the best version of yourself.

Go on – live a little, love a lot, travel far and wide. Keep moving forward and have a damn good time experiencing all that the world has to offer through the art of travel.

PREVIOUS We're all just dots in the universe. *Infinity mirrors* by Yayoi Kusama at The Broad, Los Angeles, USA
ABOVE French for 'the good life'

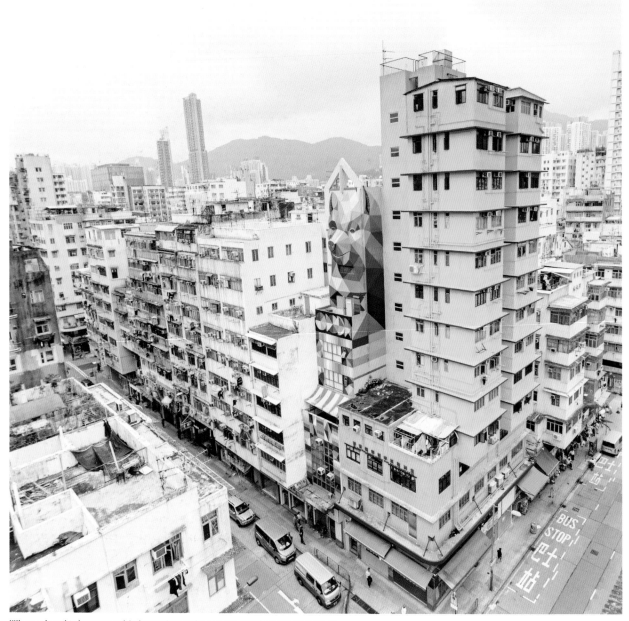

When a local takes you to his favourite rooftop views overlooking Hong Kong

# TRAVELLING CREATIVELY

**creatively /kriˈeɪtɪvli/**

(adverb)

In an original or imaginative way, using the imagination or original ideas to create something.

**Date: Wednesday 5 April 2017. Location: In transit MNL > HKG.**

We're living in a pretty incredible time in history in terms of the way we work. With the sweet interwebs in existence, we're given numerous opportunities to find – even create – work that aligns with our passions. It's a previously unconventional way of living you can now see people doing every day; remote work, online consulting, entrepreneurship and the ranks of freelancing creatives are growing, steadily and fast.

I'm on the way to Hong Kong with Cathay Pacific to simply explore and capture a #LifeWellTravelled. It's also the first time I have taken a travel partner with me in Business Class. He just threw the hot towel he was handed on arrival at me. Boys.

We are travelling creatively: noting the things we are drawn to and interested in and then doing them. Most of these things involve photography spots, temples, shopping, cafes, oh and dumplings, can't forget the dumplings. We're also connecting with a local Instagrammer who will take us to see skyscraping views from secret Hong Kong rooftops. Then there's a photography meet-up towards the end of the trip for a chance to see the city at night and upskill on night photography. I've been to Hong Kong numerous times before but I'm excited to be seeing the city differently – creatively.

Plus I have my own personal paparazzo this time. A doña could get used to this.

—

When you travel creatively, you discover new interests and develop the old.

It isn't about doing only the things that articles and guidebooks say are the best things to do in a place – it is seeing travel as an opportunity to expand your interests so you can engage in a more meaningful way with your ethics and the values that you personally believe in. It is a way to further develop talents, bring to the surface new skills and techniques, establish friendships with similar minds – and different ones, too. And even get a good view of a city by having a local sneak you into apartment blocks to show you around.

**CAPTURE THAT.**

# TRAVELLING CURIOUSLY

**curiously /ˈkjʊərɪəsli/**
(adverb)
In a way that shows eagerness to know or learn something.

**Date: Monday 30 May 2016. Location: Melbourne, Australia.**

Passport: check. Camera: check. The replacement of fear with curiosity: working on it.

I am setting out on the biggest adventure of my life so far: a solo trip to South America that has come out of saying 'yes' to a job for PayPal happening in Brazil in early June. I'm flying all the way across the world – more than 24 hours – and it would've been silly if I hadn't extended my stay beyond this long-weekend stint in Rio de Janeiro to capture the city just before the Olympics, especially because I've never been to South America before. My heart is more curious than ever. Frightened, for sure, but nonetheless excited about what's in store over the next couple of months. I'm heading to Brazil, Peru, Colombia and Chile. And the only plans I have are no plans.

Leaving things to chance creates an openness so you can purposefully follow the things that cross your path, such as exploring the local food and culture, or talking to locals to find out what daily life is like.

I have had the chance to experience so many incredible things that I never anticipated would come with creating and managing a travel blog, a few of which have left me with mixed emotions. At times

I have wondered if I'm missing the thrill of the true concept of travel simply because I'm always looked after, catered for, picked up and dropped off, so I can capture a destination and document it as my job. I'm not complaining, but I think about this conflict constantly and thoroughly.

That's why I've decided that the underlying purpose of my solo travels in South America (after I've finished the travel job, of course) is to embrace spontaneity for two months – to just 'see what happens'.

—

When you travel curiously, you travel with an open mind. You find the best source of inspiration through human interaction – in the conversations that you have with the people you encounter. It's an ever-changing dialogue that allows you to learn openly from a different culture.

Travelling curiously means you don't just travel. You are open to the new, engage with the culture you find yourself in and explore new aspects of your interests and passions. You learn, change, gain courage; you adapt, evolve and conquer fears. When you travel curiously, the magic unfolds, and there it is.

**YOUR OWN STORY.**

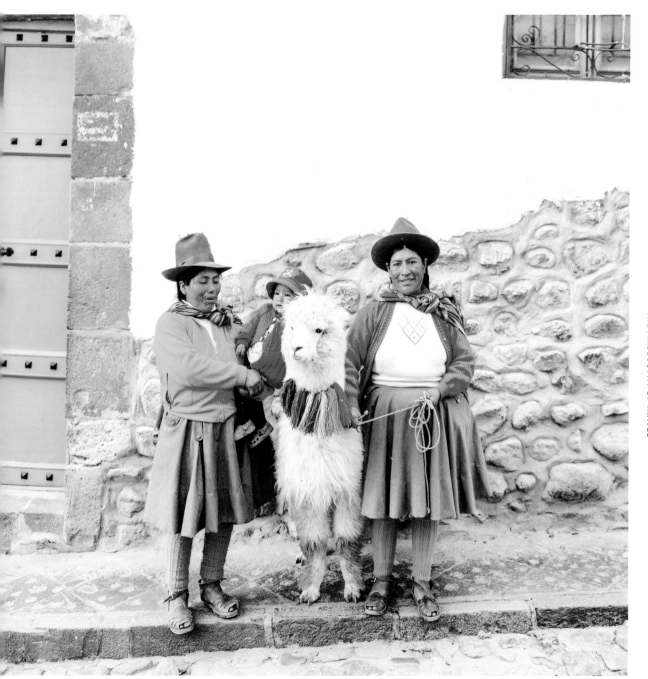

They were just taking their llama out for the afternoon in Cusco, Peru

# TRAVELLING MINDFULLY

**mindfully /ˈmʌɪn(d)fʊli/**
(adverb)
In a way that shows consciousness or awareness of something, such as focusing one's awareness on the present moment.

**Date: Saturday 26 December 2015.**
**Location: Tasmania, Australia.**

I'm spending this New Year's doing something completely different from what I'd usually do at this time of year. For the next ten days I'll surrender my phone, camera, personal belongings and speech and avoid physical contact with any other being in order to practise Vipassana, a meditation technique involving concentration on the body and its sensations: a clear awareness of exactly what is happening as it happens. This retreat is most well known for its ten days of silence, but I will find this the least difficult part of my time here.

I'm going in with no expectations (I have only a vague idea from my partner of what's involved) and am curious to see how I will go. A few of the other people who have completed it before say that it's not until afterwards – when you return to the 'real' pace of everyday life – that you notice the benefits of it.

I'm always open to change.

This experience will change my life – or at least my perception of it.

—

When you travel mindfully you are truly living in the moment, in a state of active, open, intentional attention on the present. Not stuck in the past or worried about the future; your mind is free from the anxiety of what you think will happen so you can embrace what is actually happening.

Up in the clouds in Melbourne, Australia

Take a moment to look around. What do you see, hear, smell? Notice it, acknowledge it, engage with it, then let it go. This is how you apply mindfulness to your travel experience. Finding it tricky? Perhaps these tips will help.

→ When you travel, let go of all the expectations you may have of the trip and be open to what is happening instead.

→ Instead of cramming your itinerary with monuments to see which will have you rushing to get from point A to point B, walk to simply walk – just as we dance to simply dance. Explore this new place with all of your senses: note how the grass feels under your feet, how the wind feels on your skin, the scents in the air.

→ Eat slow. Enjoy what's happening right now and stop thinking or comparing the meal to any other meal you have had. Instead, notice the textures, separate the flavours: taste the food.

→ Put down your phone and have a face-to-face conversation: talk to locals, engage in their culture, learn the language, roam the streets – look up.

→ When unexpected mishaps occur (as they inevitably will) and at times of frustration or anxiety, breathe. Set emotions aside. Then figure out a rational solution.

Know that all these moments – whether pleasant or unpleasant – will change, and that's just the beauty of life. Learn to embrace change and you'll be happy.

Be here now.

Make this moment a good one.

**MAKE THEM ALL MEMORABLE ONES.**

Canola fields under the Australian sun

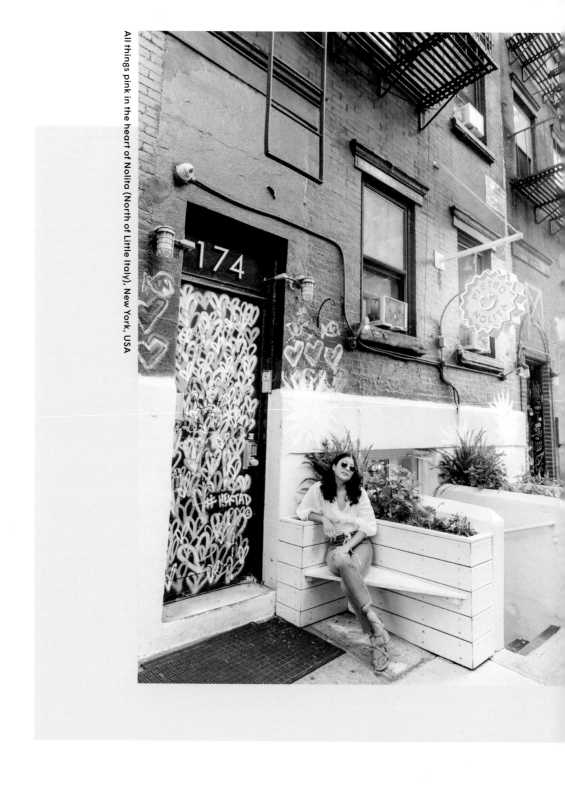

All things pink in the heart of Nolita (North of Little Italy), New York, USA

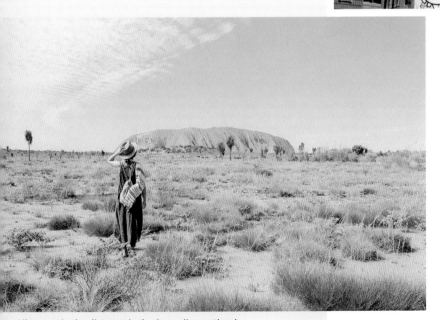

Uluru out in the distance in the Australian outback

229

**How to say thank you in 25 languages**

Arabic – Shukran

Bosnian – Hvala

Catalan – Gràcies

Croatian – Hvala

Danish – Tak

Dutch – Dank je

Filipino – Salamat

French – Merci

German – Danke

Greek – Efcharistó

Hindi – Dhanyavaad

Indonesian – Terima kasih

Italian – Grazie

Japanese – Arigatô

Korean – Gomabseubnida

Mandarin – Xièxiè

Norwegian – Takk

Portuguese – Obrigado (masculine) / Obrigada (feminine)

Russian – Spasibo

Spanish – Gracias

Swahili – Asante

Swedish – Tack

Thai – Kop khun

Ukrainian – Dyakuyu

Zulu – Ngiyabonga

# ACKNOWLEDGEMENTS

All the kind souls, creative minds, wild hearts, and curious readers of The Love Assembly, thank you a million for being by my side from the very beginning.

Melissa Kayser and the team at Hardie Grant Travel, thank you for believing in me, and my editors Megan Cuthbert and Eugenie Baulch thank you for your advice, being my sounding boards and working alongside me.

To my travel partners, photographers, friends, lovers, nomads and vagabonds I met on the road while creating this, thank you for your company, capturing these moments, and your patience in taking direction to help my vision come to life. I truly appreciate it.

My family, thank you for allowing me to explore, especially solo (even if I know you hate it Ma), I love you all.

And of course to you, thank you for reading and supporting this journey.

~ Gracias la vida.

Never lose that spark of everyday magic.
Never stop learning. Never stop exploring.

SHARE THE LOVE on social:
@theloveassembly | #mywanderlove

Published in 2018 by Hardie Grant Travel,
a division of Hardie Grant Publishing

Hardie Grant Travel (Melbourne)
Building 1, 658 Church Street
Richmond, Victoria 3121

Hardie Grant Travel (Sydney)
Level 7, 45 Jones Street
Ultimo, NSW 2007

hardiegranttravel.com

All photos are © Aubrey Daquinag 2018 except for the following:
Jonathan Mendoza: cover image (top, middle), page 3, 4, 7, 10, 26, 101,
139, 143, 149, 151, 169, 175, 187, 203, 228; Paul Serra: page 51, 83, 156
(top); Jed Buencillo: page 197, 231

Definitions on page 221, 222 and 224 adapted from the *Oxford English
Dictionary*

Cataloguing-in-Publication entry is available from the catalogue of the
National Library of Australia at www.nla.gov.au

Wander Love
ISBN 9781741175509

10 9 8 7 6 5 4 3 2 1

**Publisher**
Melissa Kayser

**Project editor**
Megan Cuthbert

**Editor**
Eugenie Baulch

**Proofreader**
Susan Paterson

**Designer**
Grosz Co Lab

**Typesetter**
Megan Ellis

Pre-press by Splitting Image Colour Studio
Printed in China by 1010 Printing International Limited

**Cover captions**

Front cover:

Wandering through Murralla Roja
in Calpe, Spain (top)
In front of the Flatiron Building in
New York, USA (middle)
Matcha ice-cream in Kyoto,
Japan (bottom)

Back cover:

Rainbow Mountain, Peru